MERMAIDS

Mermaids

SIRENS OF THE SEA

by Kerry Colburn

COURAGE
BOOKS

AN IMPRINT OF RUNNING PRESS
PHILADELPHIA • LONDON

9 8 7 6 5 4 3 2 1

Digit on the right indicates the number of this printing

Library of Congress Control Number 2002095666

ISBN 0-7624-1632-7

Cover art: Mermaid weathervane by Warren Gould Roby.
© Shelburne Museum, Shelburne, VT.
Cover and interior design by Gwen Galeone
Art researched by Susan Oyama
Edited by Joelle Herr
Typography: Attic, Houston, and Dante

This book may be ordered by mail from the publisher.
But try your bookstore first!

Published by Courage Books, an imprint of
Running Press Book Publishers
125 South Twenty-second Street
Philadelphia, Pennsylvania 19103-4399

Visit us on the web!
www.runningpress.com

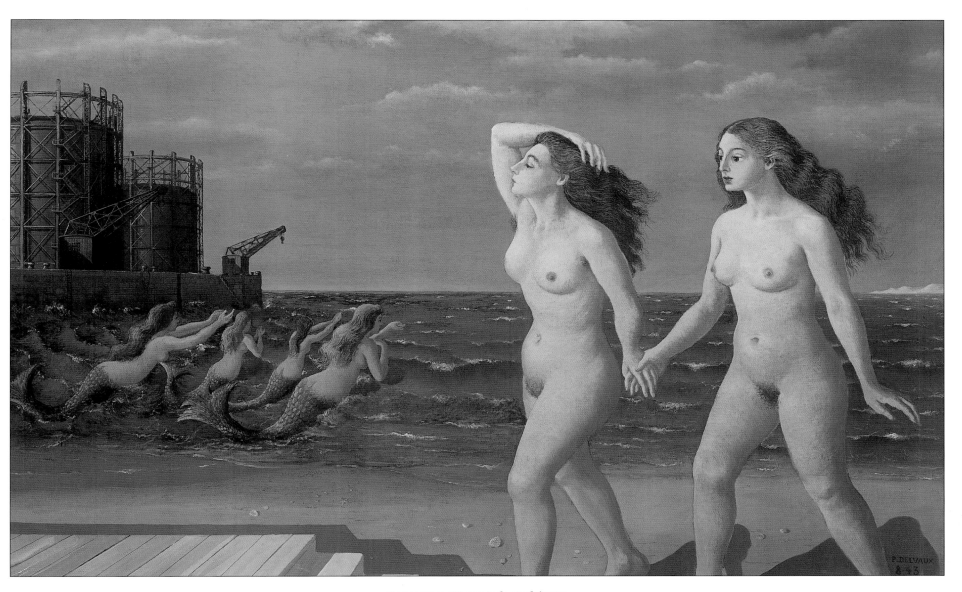

Composition, Woman in front of the Sea
Paul Delvaux
1943
Oil on canvas

INTRODUCTION

ermaids, sirens, and water nymphs have been darting in and out of our collective consciousness since the beginning of recorded time, luring us from our orderly, landlocked existence into their strange, dream-like realm under the sea. And we repeatedly dive into the waves to follow them.

Why? Because mermaids are mysterious, alluring, the keepers of secrets, and the possessors of irresistible, beckoning voices. They are beautiful. They are dangerous. They are shameless flirts. In legends and folklore from around the world, they have bestowed riches, played cruel tricks, given up their lives, fallen madly in love with humans, and caused a wide range of death and destruction. With the torsos of flawless maidens and the lower halves of fish (or sometimes seabirds), they are the embodiment of both feminine wiles and feminine wisdom, seductive creatures who seem to hold the fulfillment of any deep desire a seafaring man might harbor.

But even if you look beyond the naughty reputation mermaids have gained via the songs and stories of various cultures—not to mention Hollywood—you'll find that mermaids, at the heart of it, represent the fickle nature and mesmerizing beauty of the ocean. Long the subject of sea shanties, ballads, and ancient legends, they have coaxed some of our most romantic works of music, literature, and art out of captivated souls ranging from T. S. Eliot and William Shakespeare to Paul Gaugin and Gustav Klimt.

Goddesses, fertility symbols, independent women, forbidden lovers, and ageless beauties, mermaids, in all their forms, beckon us back, again and again, to leave the safety of solid ground and plunge headfirst into the complex mysteries of the sea.

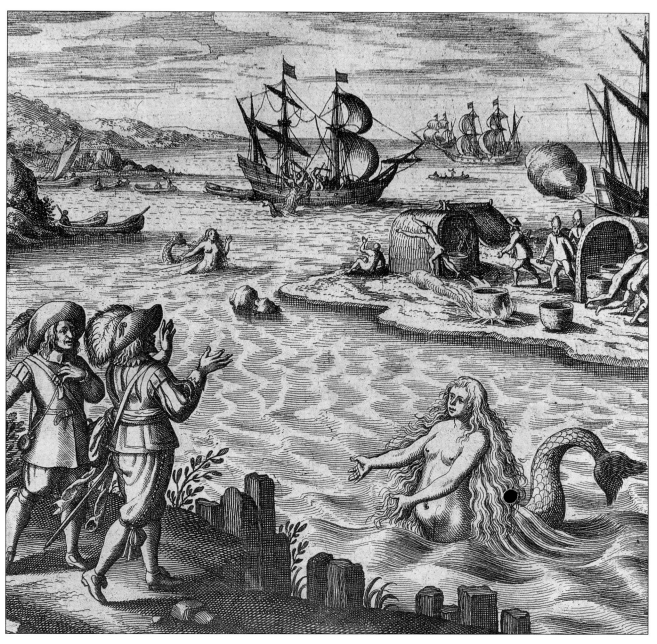

Capt. Hailborne at St. Johns Newfoundland
Book illustration from *Newe Welt vnd Americanische Historian*
1655
Line engraving on paper

But remember always, as I told you at first

that this is all a fairy tale,

and only fun and pretense; and, therefore,

you are not to believe a word of it, even if it is true.

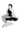

—*Charles Kingsley*
(1819–1875)
BRITISH WRITER

The Triumph of Neptune
Frans II the Younger Francken
First-half 17th century
Oil on copper

Since once I sat upon a promontory,

And heard a *mermaid* on a dolphin's back

Uttering such dulcet and harmonious breath,

That the *rude sea* grew civil at her song,

And certain stars shot madly from their spheres

To hear the *sea-maid's* music.

—*William Shakespeare*
(1564–1616)
BRITISH PLAYWRIGHT AND POET

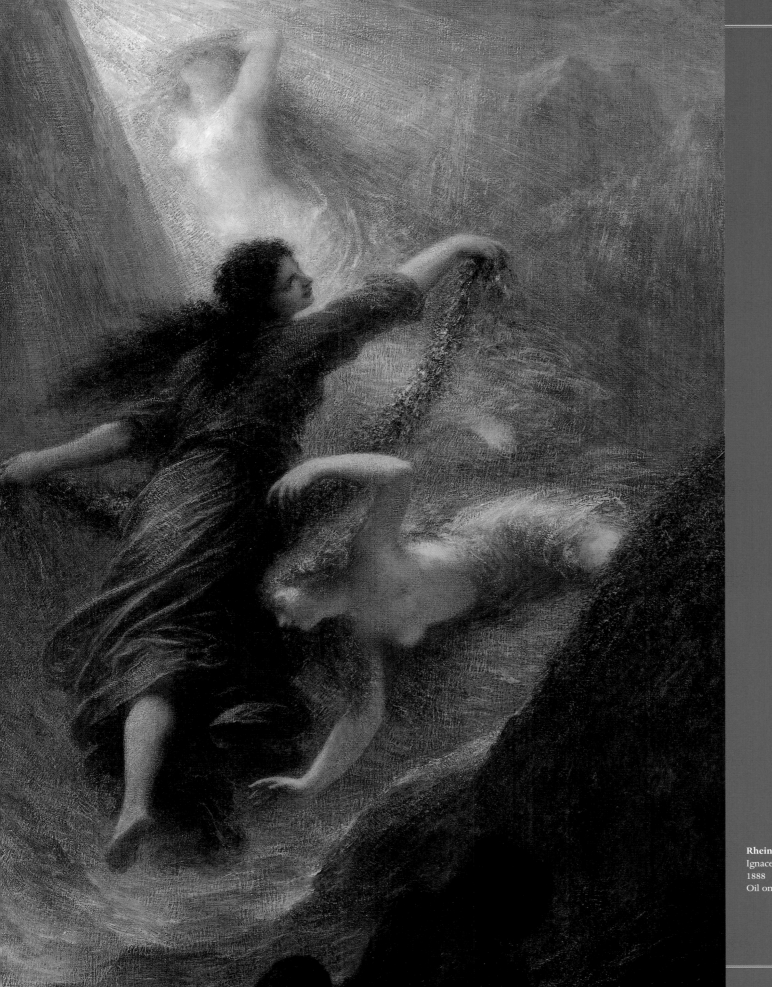

Rheingold, first scene
Ignace Henri Jean Fantin-Latour
1888
Oil on canvas

THE SEA HAD JEERINGLY KEPT HIS FINITE BODY UP,

but drowned the infinite of his soul. Not drowned entirely, though. Rather carried down alive to wondrous depths, where strange shapes of the unwarped primal world glided to and fro before his passive eyes; and the miser-merman, Wisdom, revealed his hoarded heaps; and among the joyous, heartless, ever-juvenile eternities, Pip saw the multitudinous, God-omnipresent, coral insects, that out of the firmament of waters heaved the colossal orbs. He saw God's foot upon the treadle of the loom, and spoke it.

—Herman Melville
(1819–1891)
AMERICAN WRITER

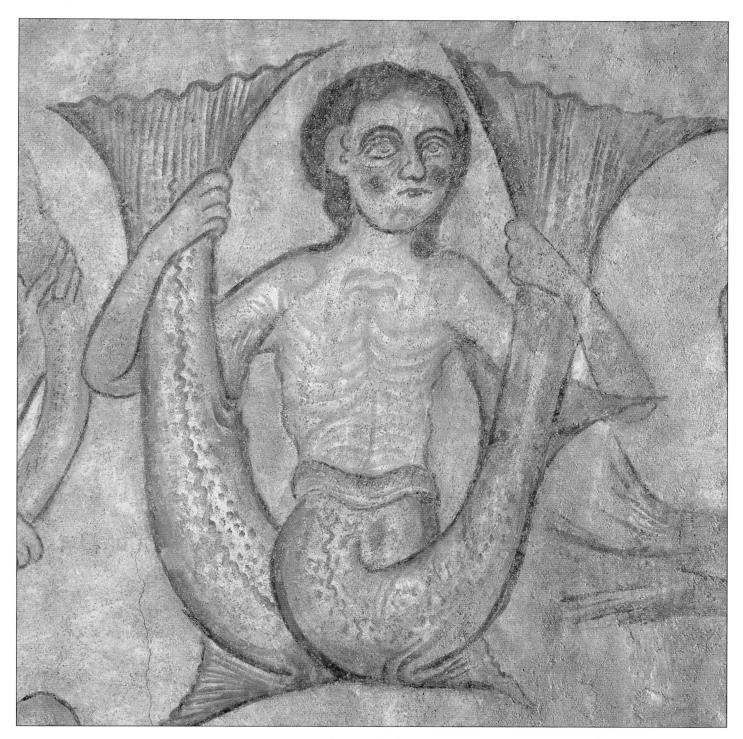

Anthropomorphic figure
Italian school
15th century
Fresco

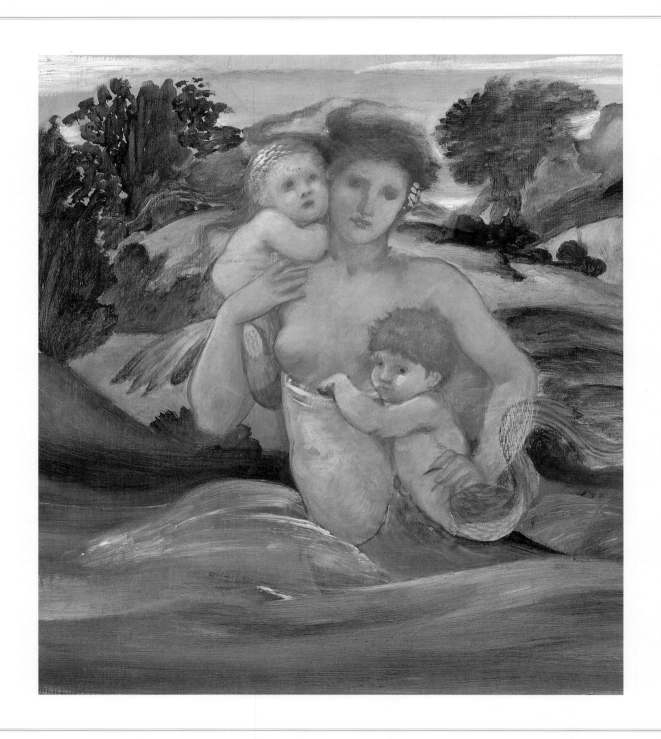

Mermaid with Her Offspring
Sir Edward Burne-Jones
ca. 1860–1898
Oil on canvas

Wide sea, THAT ONE CONTINUOUS MURMUR BREEDS
ALONG THE PEBBLED SHORE OF MEMORY!

—*John Keats*
(1795–1821)
BRITISH POET

A mermaid found a swimming lad,

Picked him for her own,

Pressed her body to his body, laughed;

And plunging down

Forgot in cruel happiness

That even lovers drown.

—*William Butler Yeats*
(1865–1939)
IRISH POET

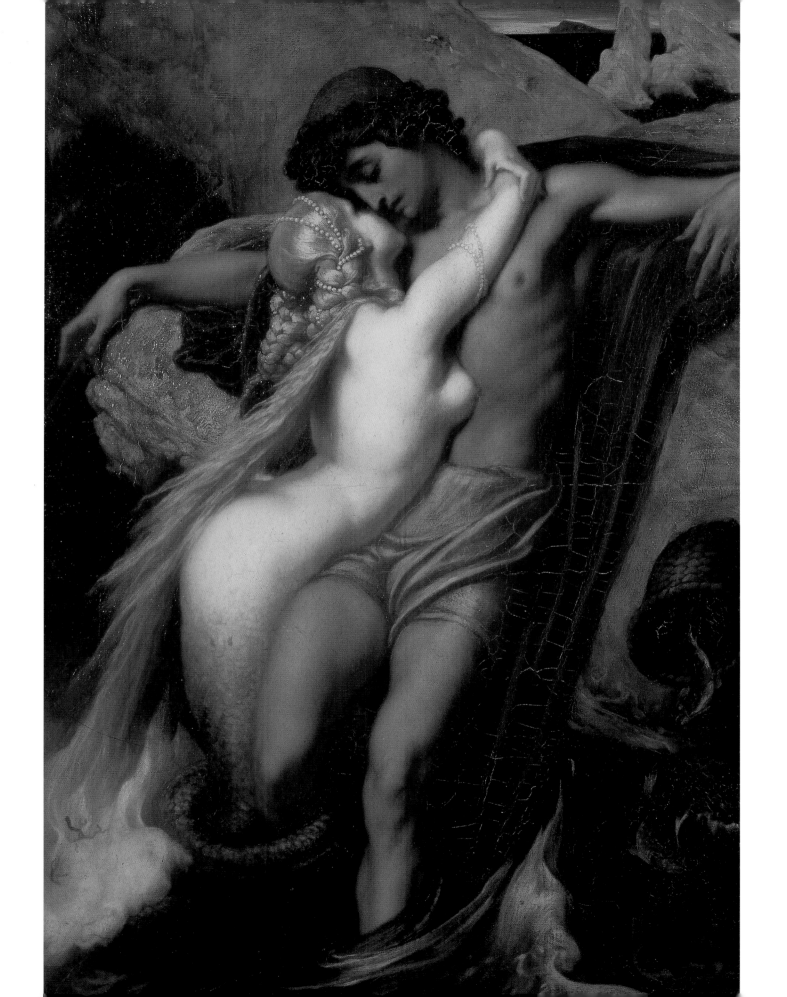

HANSI AND THE NIX

n Switzerland, in the Lake of Zug, there lived a water nymph called a nix.

When the nix was in the lake, she had a tail just like any mermaid. But when

the nix emerged onto land, she had legs like a human girl. One summer day,

she sat on the shore, peering at herself and singing:

> *"Go call the Swiss cow,*
> *Go call the Jersey.*
> *They must all come, they must all come,*
> *All come into the barn."*

A pebble skipped across the water as she sang, and she heard a young male voice yodeling

behind her: *"Hol-de-ree-dee-ah, dee-ah!"*

"Stop that," commanded the nix, "You're ruining my song." She turned to see a young man

standing next to a sweet brown cow.

"But it's supposed to have a yodel," he objected. He yodeled again, smiled, and introduced

himself. "I'm Hansi, a cowherd, and this is my cow, Klara."

The nix smiled back. She did not want to admit that she did not have a name, so she said,

"Kindly call me Nixie, sir."

Hansi and Nixie spent the afternoon together, and soon discovered that they had many

things in common, including that they both liked to eat trout and hated buttermilk; that yellow

was their favorite color even though bluebells were their favorite flower. They talked until the sky

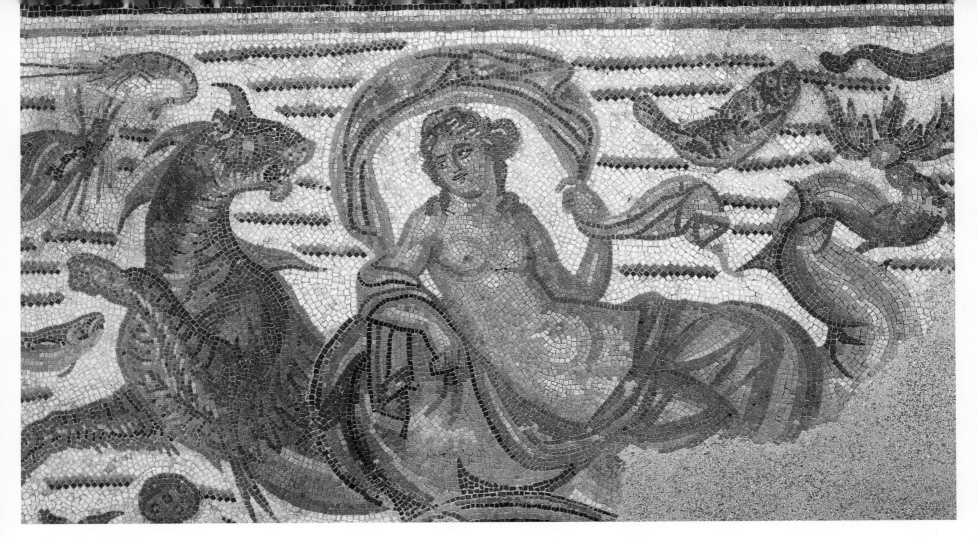

Nereid or sea nymph, detail
Roman
3rd century
Mosaic from seaside procurator's villa, Hippone, Algeria

grew dark, and Hansi said he had to return to his village—but not before promising to return the

next day to teach Nixie how to yodel.

The next day, as promised, he returned. Although she had a beautiful voice, as mermaids do,

Nixie still couldn't do yodel.

"Keep trying," said Hansi. "I'll be back again tomorrow."

Hansi returned the next day, and for all the days of summer. Nixie never tired of trying to

yodel, and Hansi never tired of trying to teach her, and the cow Klara happily munched the flow-

ers along the shore. But soon autumn came, and the cool alpine air made the nix shiver.

"Come home with me and sing by my fire," Hansi offered.

"On land, I'd get old and wrinkled," protested Nixie. "Then I wouldn't want to sing at all. Why don't you come with me instead? The water's warm at the bottom of the lake."

Hansi wasn't sure. He had heard that anyone who followed a mermaid might vanish forever.

After she promised that he could return if he was unhappy, Hansi dove into the Lake of Zug. Although he sank like a stone to the bottom, he found he could breathe easily. The two of them were happy until one day when the nix found him sitting glumly at the bottom. Hansi confessed that he was worried about Klara with the impending winter chill.

"Is that all?" asked Nixie. She didn't want him to go, so she offered to fetch his cow. Soon, Klara was at the bottom of the lake, feeding on tender water plants. Klara was content there, and so was Hansi.

When springtime came, Hansi was gloomy again. "It doesn't seem like spring without wildflowers," he said.

"Is that all?" asked Nixie. "Wait and I will fetch some for you." And she soon returned with bluebells and daisies for Hansi and dandelions for Klara, and everyone was content.

But when the long days of summer came, Hansi looked up through the water and saw the sun, round and yellow as a wheel of cheese. "The cheese I made from Klara's milk should be ripe by now," he mused. "Oh, how I would love to taste it!"

"Is that all?" asked Nixie. "Wait and I'll get it for you."

Soon ten large cheeses splashed into the lake, and Hansi was happy.

Alas, the more Nixie fetched for him, the more Hansi seemed to need. Nixie brought him his own feather bed, since he complained about sleeping on the stony ground. She brought him

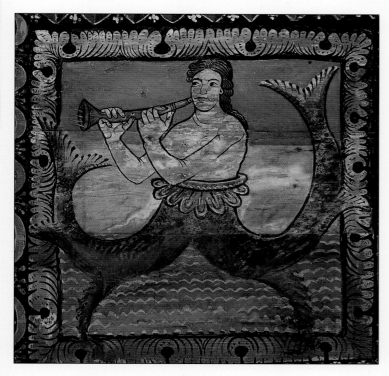

St. Martin's watersprite, detail
ca. 1160
Wood panel ceiling, St. Martin, Zillis, Switzerland

his rocking chair, his whittling knife, and his alpenhorn. She no longer had time to practice yodeling. One evening, before he had a chance to ask for anything new, Nixie said, "Just you wait, Hansi!" Then she disappeared.

Hansi waited all night until he finally fell asleep. When he woke in the morning, he saw the nix perched on a stone, and spread out around her was his village. He rubbed his eyes. He counted each shop on every street. He spotted his own house and barn, just as he remembered them. The nix had enchanted the town of Zug and brought it all down to the bottom of the lake.

"Is that all?" Nixie asked him.

"That's all," Hansi answered. "I promise."

It is said that even today, when the Lake of Zug is calm, one can sometimes make out the streets and houses of the town beneath the water. And if the air is still and you listen very carefully, you may hear a mermaid singing:

"Go call the brown cow,
Go call the black one.
They must all come, they must all come
All come into the barn."

And then, like an echo:

"Hol-de-ree-dee-ah, dee-ah!"

Go, and catch a falling star,

Get with child a mandrake root,

Tell me, where all past years are,

Or who cleft the Devil's foot.

Teach me to hear mermaids singing.

And swear

No where

Lives a woman true, and fair.

Though she were true, when you met her,

And last, till you write your letter,

Yet she

Will be

False, ere I come, to two or three.

—*John Donne*
(1572–1631)
BRITISH POET

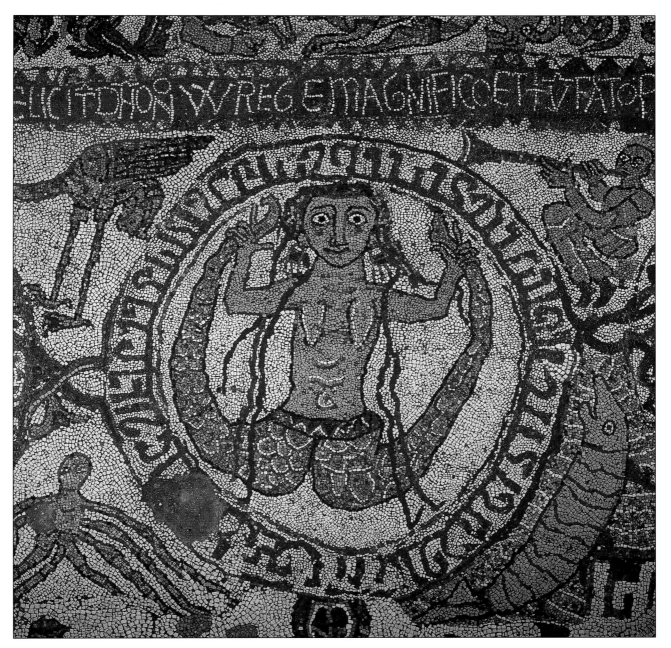

A Siren, detail
Pantaleone
12th century
Mosaic floor, Cattedrale Otranto, Italy

The Siren

WAITS FOR THEE,

SINGING SONG FOR SONG.

—*Walter Savage Landor*
(1775–1864)
BRITISH POET AND ESSAYIST

The Rhine Maidens
from Richard Wagner's *Siegfried and the Twilight of the Gods*
Arthur Rackham
1911

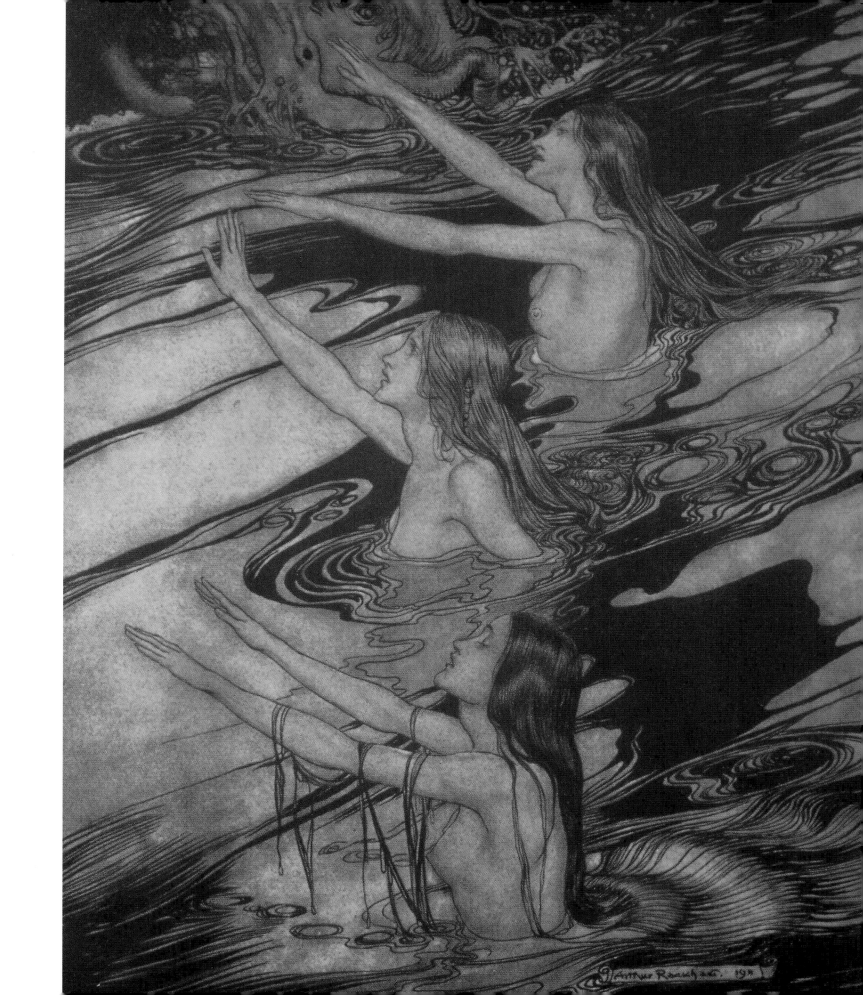

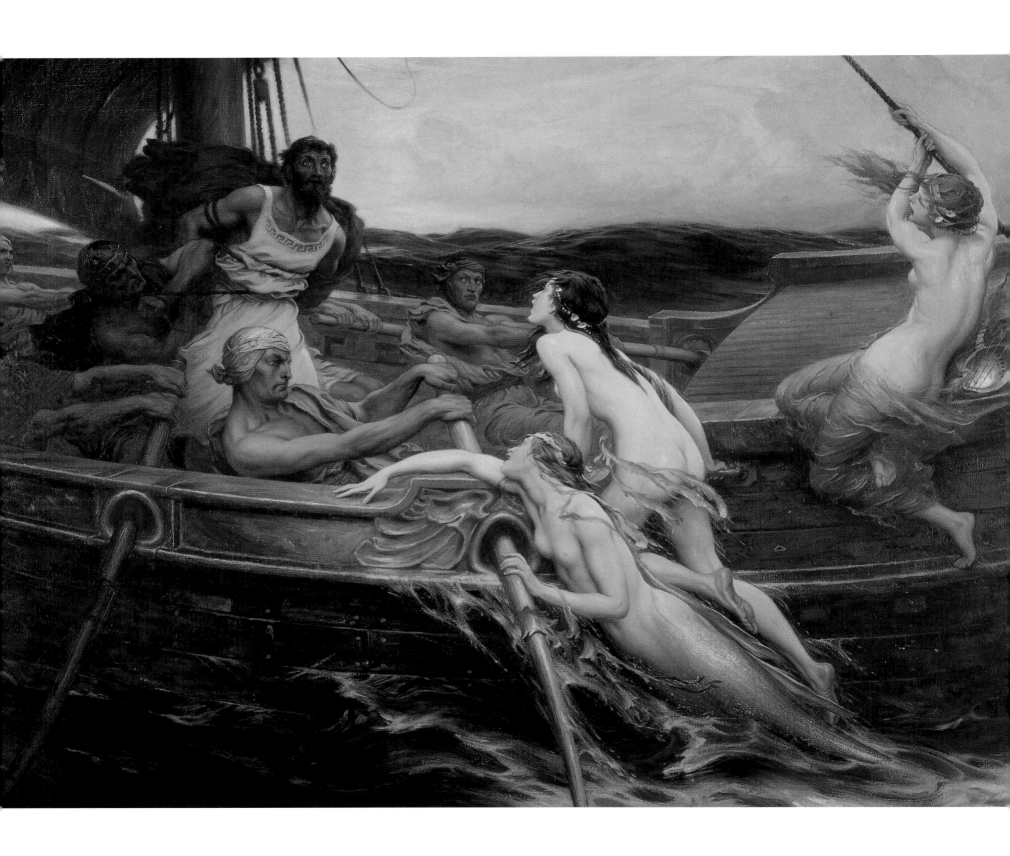

He's taken her by the milk-white hand,

And he's thrown her in the main;

And full five-and-twenty hundred ships

Sank all on the coast of Spain.

—ANONYMOUS,
"THE DAEMON LOVER"

Ulysses and the Sirens
Herbert James Draper
1910
Oil on canvas

They say THE SEA IS COLD, BUT THE SEA CONTAINS

THE HOTTEST BLOOD OF ALL, AND THE WILDEST, THE MOST URGENT.

—*D. H. Lawrence*
(1885–1930)
BRITISH WRITER

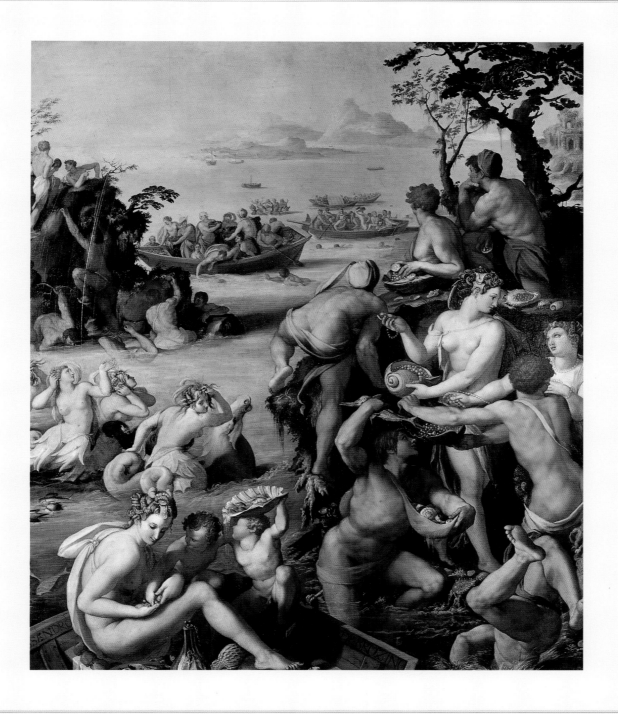

Pearl hunting
Alessandro Allori
1570–75

And the old man saw that the two Sirens,

Their brows raised,

Looked before them, straight into the sun,

Or him, or in his black ship.

And on the immobile calm of the sea,

He raised his voice, loud and strong.

"Here I am, Here I am! I have come back to know!

For I did see, just as you see me,

Only that everything I saw in the world

Saw me and made me ask: 'Who am I?'"

And the rapid sweet current

urged the ship on.

And the old man saw a large pile of human bones

And withered skin around,

Near the two Sirens, immobile

Lying still on the beach, like two rocks.

"I see. So be it. These hard bones

will increase the pile. But you two, speak to me!

But tell me the truth, one truth only among all

before I die, so I can say I have lived!"

And the rapid sweet current

urged the ship ever on.

And the two Sirens raised their gaze

to the ship, eyes set.

"I have only an instant. I beg of you!

Tell me at least who I am. Who I was!"

And between the two rocks the ship crashed.

—*Giovanni Pascoli*
(1855–1912)
ITALIAN LITERATURE SCHOLAR

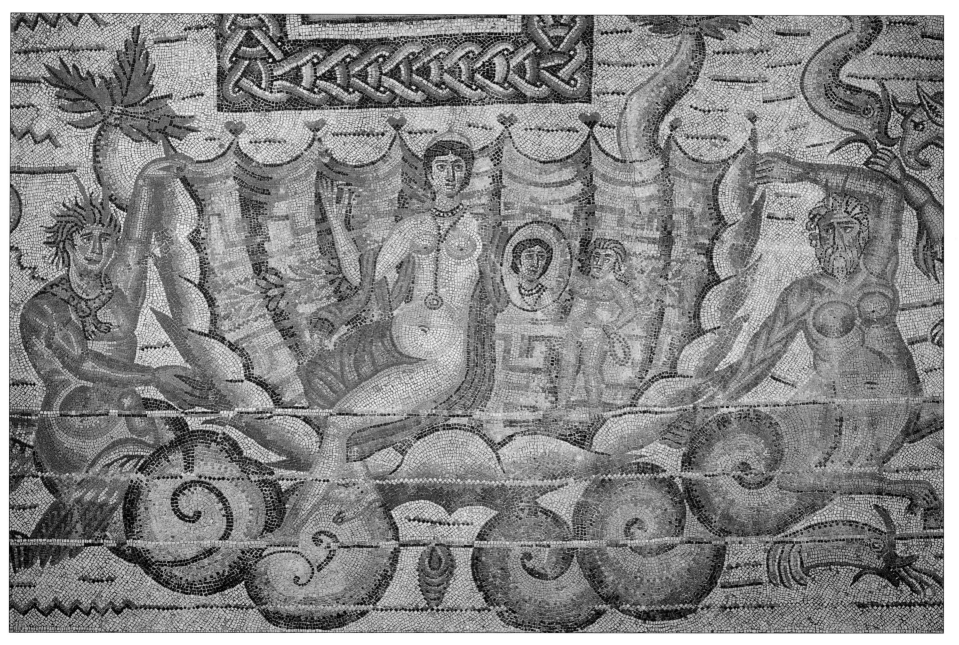

Venus at her toilette
Roman
ca. A.D. 98
Mosaic at Roman military garrison, Djemila, Algeria

Slow sailed the weary mariners and saw,

Betwixt the green brink and the running foam,

Sweet faces, rounded arms, and bosoms prest

To little harps of gold; and while they mused,

Whispering to each other half in fear,

Shrill music reach'd them on the middle sea.

—*Alfred Lord Tennyson*
(1809–1892)
BRITISH POET

Allegory on the operas of Giacomo Puccini
1900
Watercolor

What fairy-like music steals over the sea,

ENTRANCING OUR SENSES WITH CHARMED MELODY?

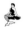

—Mrs. C. B. Wilson
(1797–1846)
BRITISH WRITER

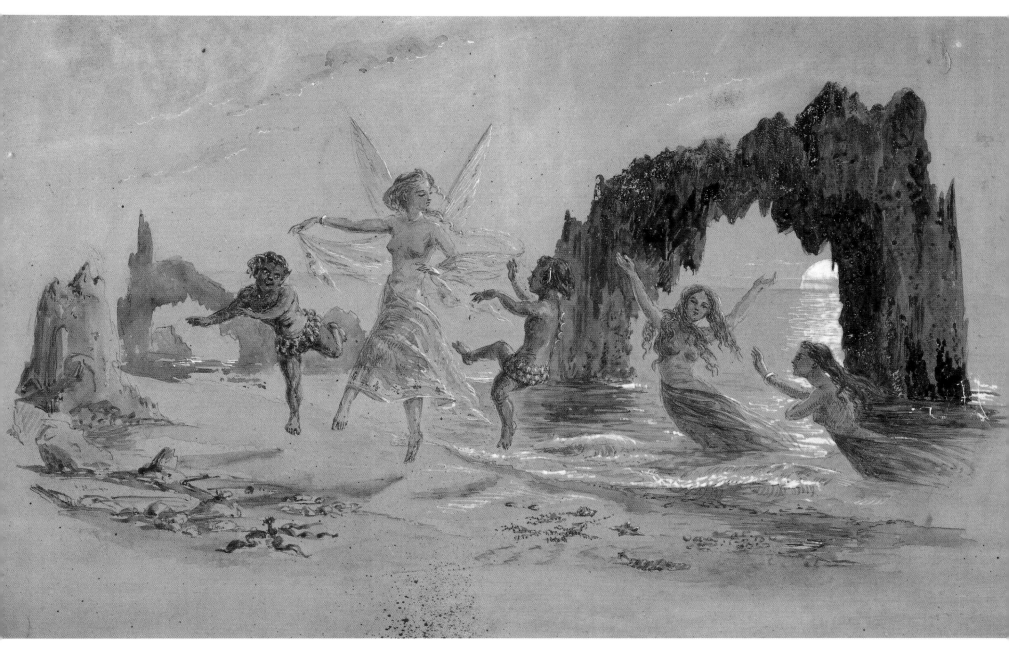

Fairies and Fauns on the Seashore
Alfred Thompson
19th century
Watercolor

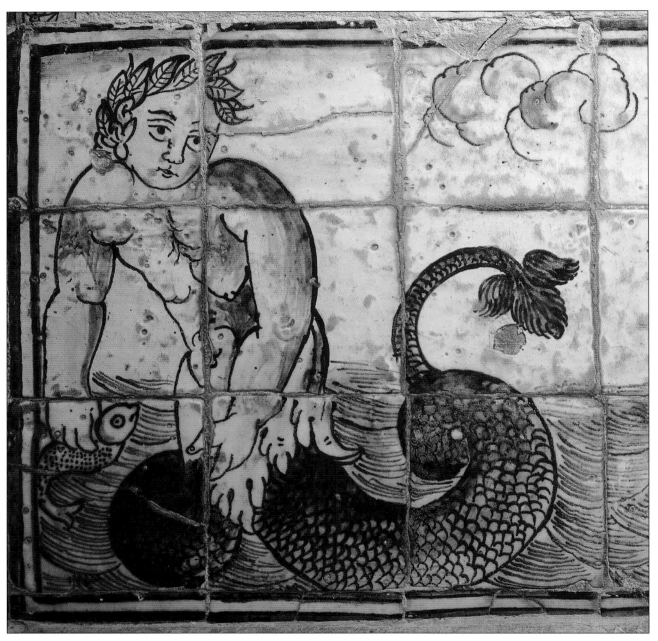

Sea monsters or mermen
late 17th century
Tiles from Palacio de los Fronteira, Lisbon, Portugal

SIREN:

Come worthy Greek, Ulysses, come,

Possess these shores with me;

The winds and seas are troublesome,

And here we may be free.

Here may we sit and view their toil

That travail in the deep,

And joy the day in mirth the while,

And spend the night in sleep.

ULYSSES:

Fair nymph, if fame or honour were

To be attain'd with ease,

Then would I come and rest me there,

And leave such toils as these.

But here it dwells, and here must I

With danger seek it forth;

To spend the time luxuriously

Becomes not men of worth.

—Samuel Daniel
(1562–1619)
BRITISH POET

I will

NEITHER YIELD TO THE SONG OF THE

SIREN NOR THE VOICE OF THE HYENA,

THE TEARS OF THE CROCODILE NOR

THE HOWLING OF THE WOLF.

—George Chapman
(1559?–1634)
BRITISH PLAYWRIGHT AND POET

The Dance of the Sea
Charles Edouard Boutibonne
1883
Oil on canvas

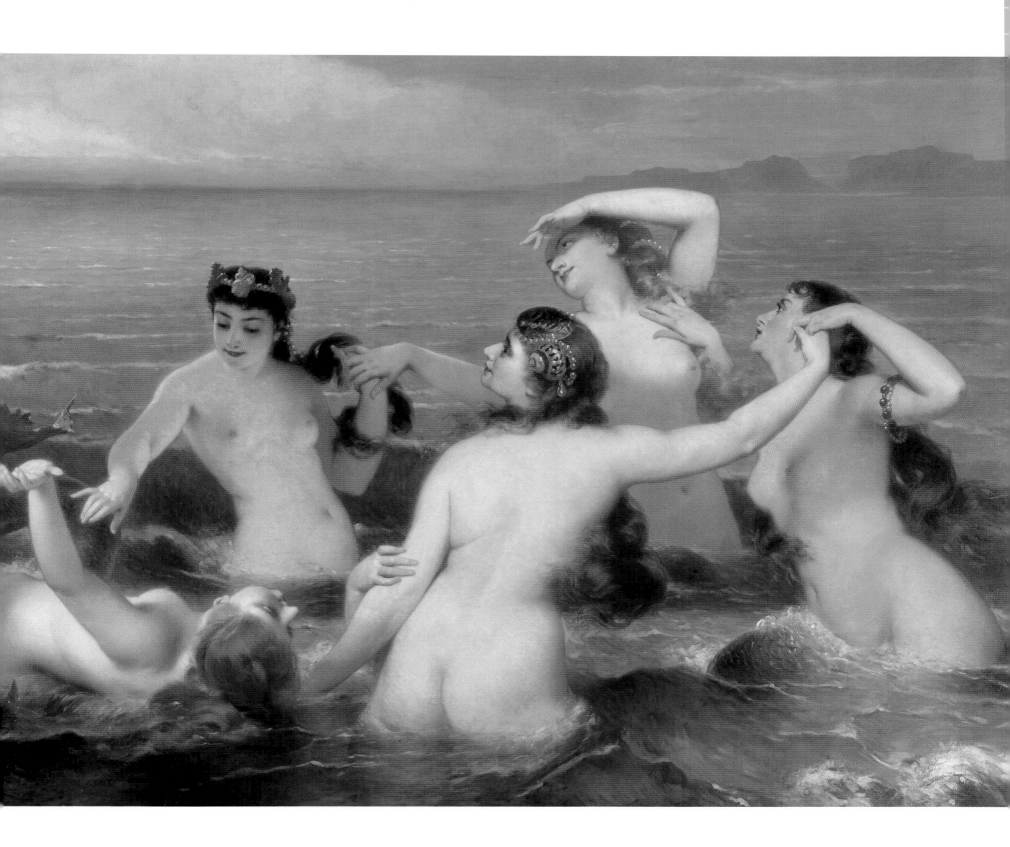

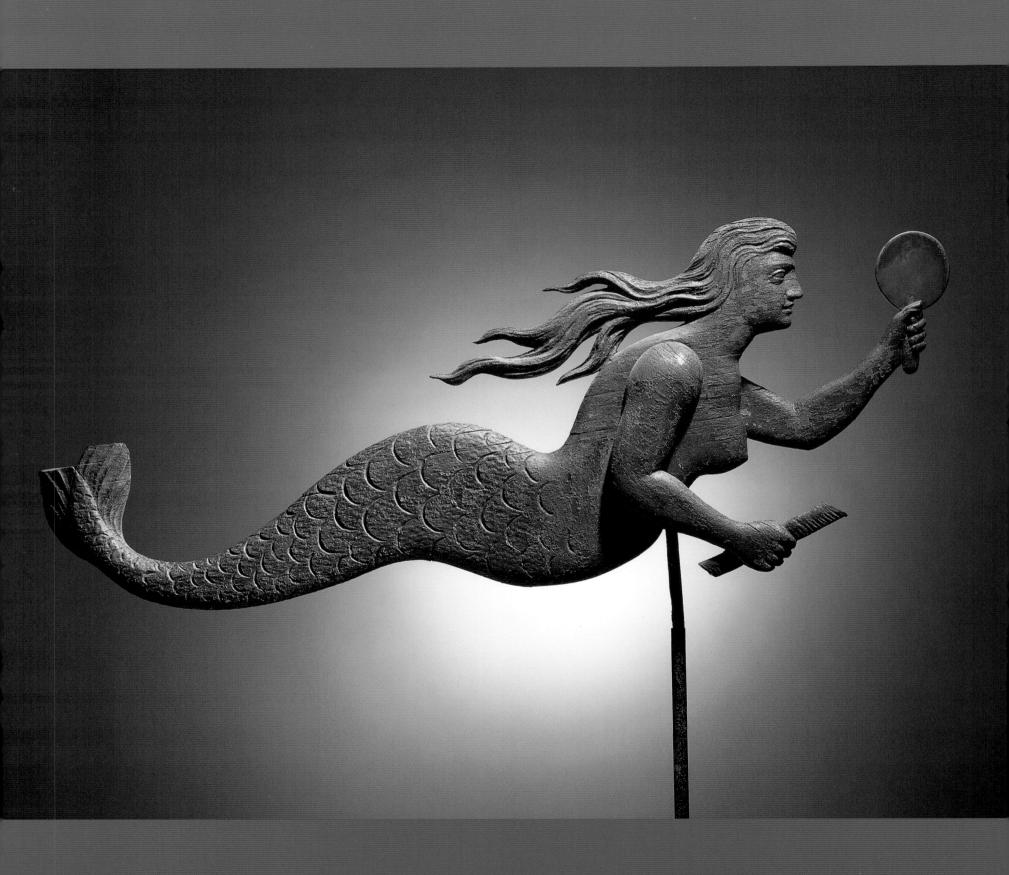

I WOULD COMB MY HAIR TILL MY RINGLETS WOULD FALL

LOW ADOWN, LOW ADOWN,

FROM UNDER MY STARRY SEA-BUD CROWN

LOW ADOWN AND AROUND,

AND I SHOULD LOOK LIKE A FOUNTAIN OF GOLD

SPRINGING ALONE

WITH A SHRILL INNER SOUND,

OVER THE THRONE

IN THE MIDST OF THE HALL;

TILL THAT GREAT SEA-SNAKE UNDER THE SEA

FROM HIS COILED SLEEPS IN THE CENTRAL DEEPS

WOULD SLOWLY TRAIL HIMSELF SEVENFOLD

ROUND THE HALL WHERE I SATE, AND LOOK IN AT THE GATE

WITH HIS LARGE CALM EYES FOR THE LOVE OF ME.

AND ALL THE MERMEN UNDER THE SEA

WOULD FEEL THEIR IMMORTALITY

DIE IN THEIR HEARTS FOR THE LOVE OF ME.

—*Alfred Lord Tennyson*
(1809–1883)
BRITISH POET

Mermaid weathervane
Warren Gould Roby
ca. 1850
Carved wood and metal

ODYSSEUS AND THE SIRENS

The story of the Sirens, whose seductive voices lured sailors to wreck their ships on the rocks, has been told and retold countless times; it is among the oldest recorded mermaid tales. In the original Greek myths, however, the Sirens were not beautiful water nymphs, but birds with women's heads and breasts. It was not their beauty that lured men to their doom, but the sweetness of their songs. In later tellings, they are described as mermaids, though still with irresistible voices. No matter their physical characteristics, the Sirens and their songs represented, for sailors, the peril of being lulled and distracted from the dangers of the sea.

According to Greek mythology, Odysseus and his men landed on an island belonging to an enchantress named Circe. After surviving her enchantments—including his men being temporarily turned into pigs—they were at last ready to forge on with their journey. When they realized they would be passing the Island of the Sirens on their route, Circe suggested that Odysseus order his crew to stuff their ears with beeswax. "Clever Circe," he exclaimed, "The goddess of wisdom herself could not give better advice."

The crew set sail and when they came near the Sirens, the men duly plugged their ears with wax and Odysseus himself asked to be lashed to the ship's mast. The music was so beautiful that he strained at the ropes as the Sirens swam toward the boat. "Come, come!" they coaxed, hold-

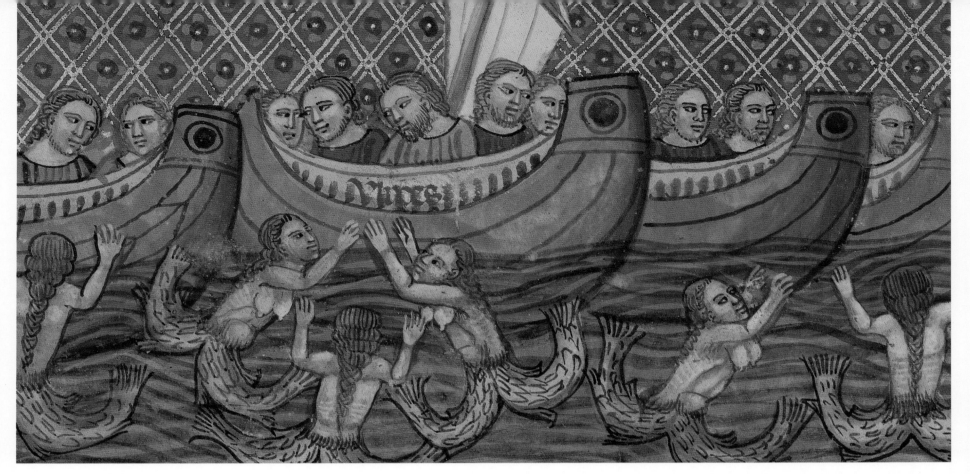

Sirens accompanying the boats
Benoit de Ste. Maure
15th century
Miniature from the Roman de Troie

ing out their arms. "We will give you wisdom; join us in the sea!" He shouted to the crew to untie

him, but they could not hear him.

Odysseus was overcome with longing, and he howled and cried and begged, but the unheeding

sailors kept steadily rowing, pulling the ship safely past the Island of the Sirens.

The music faded slowly behind them. When Odysseus could no longer distinguish a single

note, he raised his head and looked back across the sea. He could no longer see the sirens, but he

was horrified to see their island in the distance: It was littered with human bones and skulls.

Other men who listened to the Sirens had not been as lucky as he.

His men found him spent and bloody when the came to remove him from his bonds.

Odysseus told them to set their course for Ithaca, and Odysseus continued his long journey home.

Sirens, sweet fruit of the sea,

BIRD-MAIDENS, LIVED AMONG THE WAVES OF SCYLLA AND CHARYBIS.

THEIR SACRED MUSIC, GENTLE DANGER OF THE SEA, WAS PLEASURABLE

TERROR AMONG THE WAVES. ON THE KEEL OF THE SHIP LINGERED THE

CARESSING AIR, WHILE FROM AFT, A VOICE INVADED THE SHIP. BUT THE

SEAMAN LONGED NOT TO TAKE THE SECURE ROUTE HOME. BUT THERE

WAS NO PAIN; JOY ITSELF DEALT DEATH.

—*Claudianus*
(A.D. 370?–404)
LATIN POET AND PHILOSOPHER

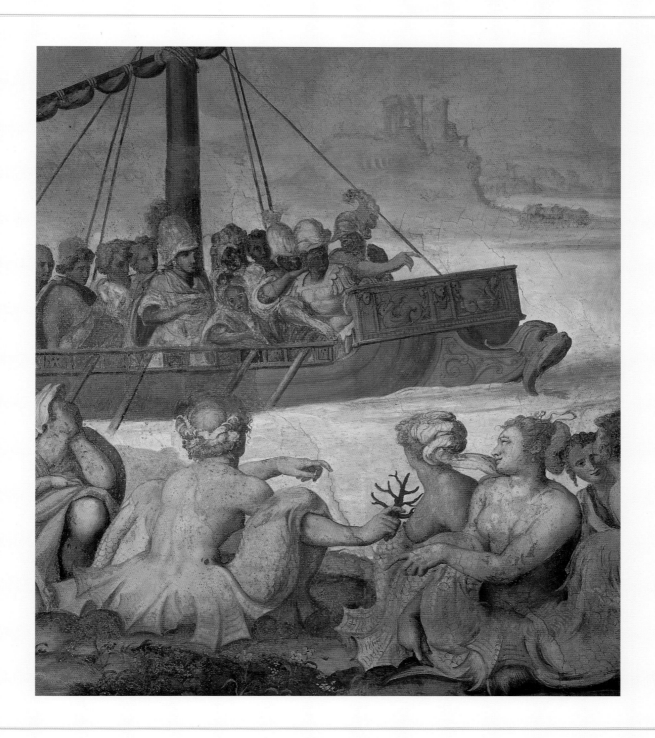

The Sirens from the Ulysses Cycle
Alessandro Allori
1580
Fresco

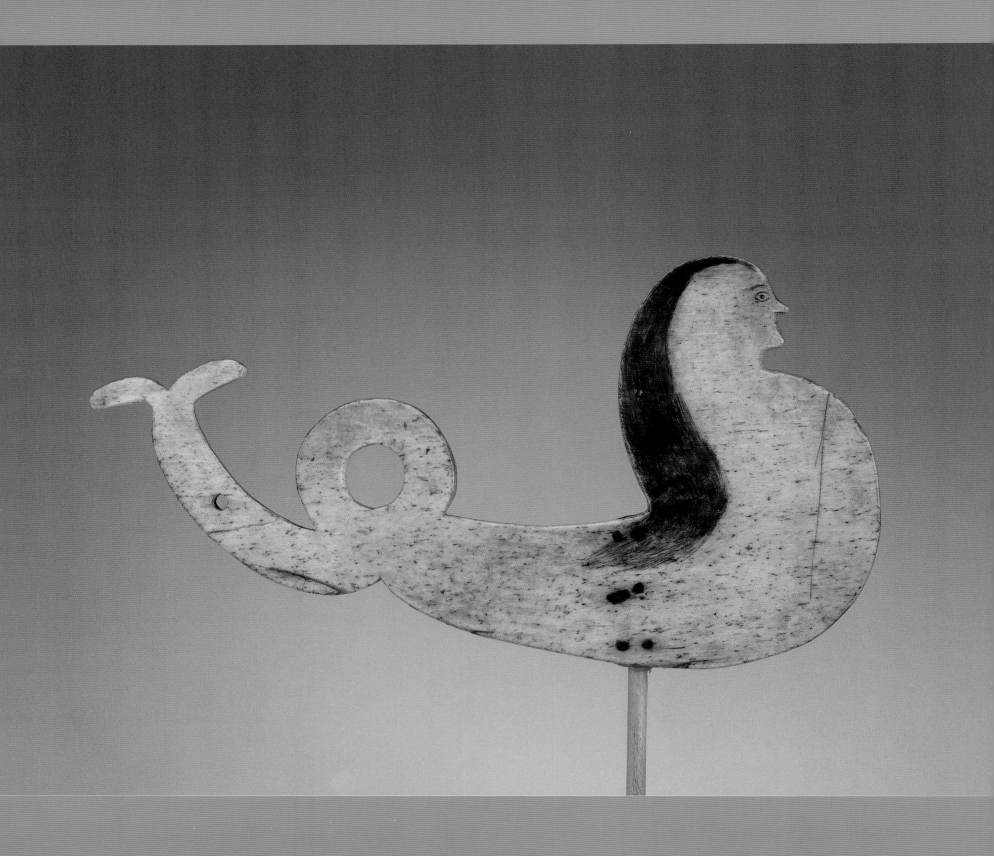

In
the crystal stream of ocean

Fishes glide with tranquil motion,

Float in life that's sorrow free;

Yet your throngs, in splendor moving,

Show your festal spirit, proving

How much more than these ye be.

—Johann Wolfgang von Goethe
(1749–1832)
GERMAN POET AND NOVELIST

Mermaid
1825–50
Ink on carved whalebone with iron

AND WHEN THE HORRIBLE MONSTERS WITH HARMONIOUS VOICE

Enchanted the waves of Ausonia

The sound of Orpheus the Thracian's lyre

Almost forced the Sirens who beckon ships

To follow that sound.

And, as prize for this bold voyage:

The golden fleece and Medea

Worse than the calamitous seas,

Just reward for the first ship.

—Seneca
(4 B.C.– A.D. 65)
ROMAN STATESMAN AND PHILOSOPHER

One Thousand and One Nights
Marc Chagall
ca. 1940s
Lithograph

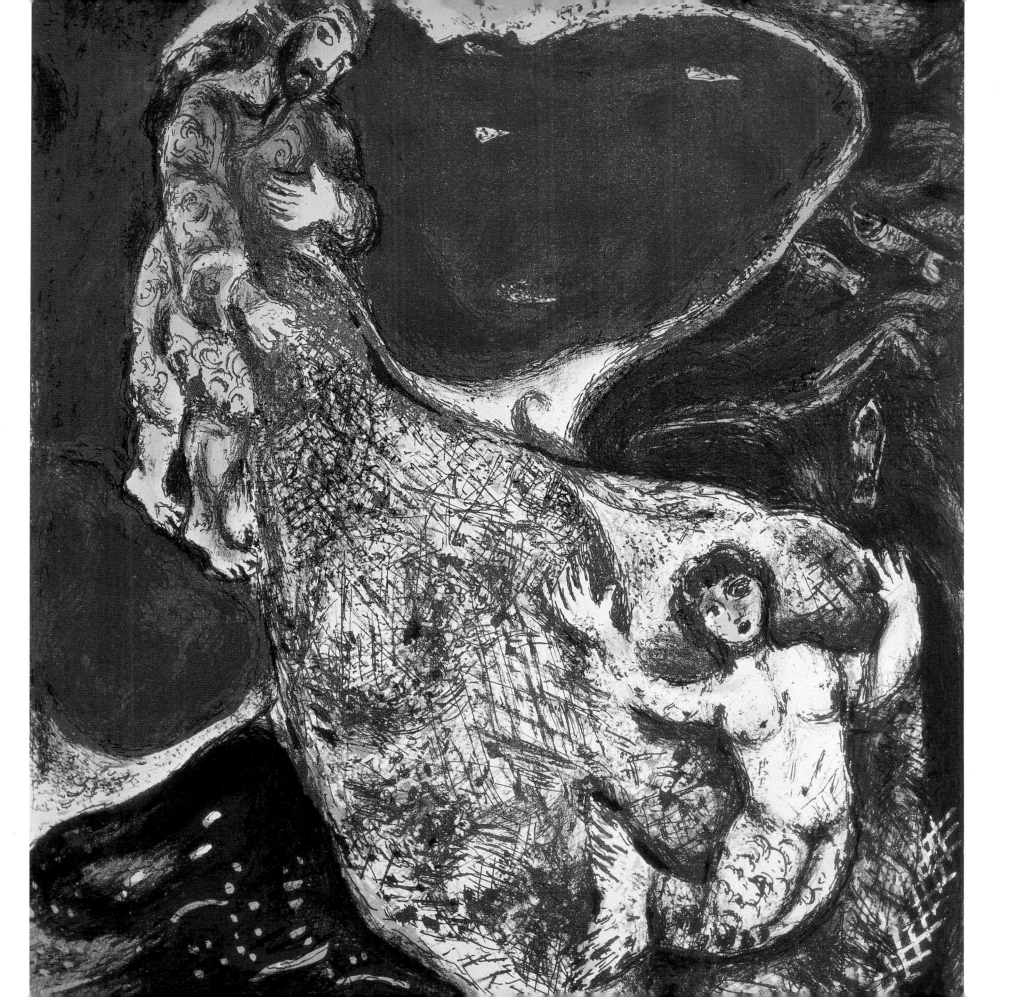

ull fathom five thy father lies:

Of his bones are coral made;

Those are pearls that were his eyes:

Nothing of him that doth fade

But doth suffer a sea-change

Into something rich and strange.

Sea-nymphs hourly ring his knell:

Hark! now I hear them,—

Ding, dong, bell.

—*William Shakespeare*
(1564–1616)
BRITISH PLAYWRIGHT AND POET

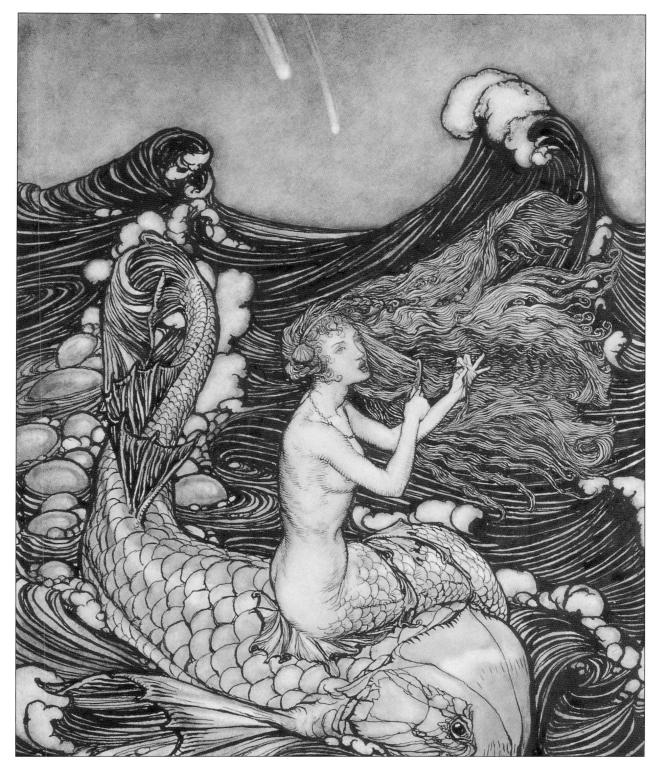

Mermaid and Dolphin from *A Midsummer Night's Dream*
Arthur Rackham
1908

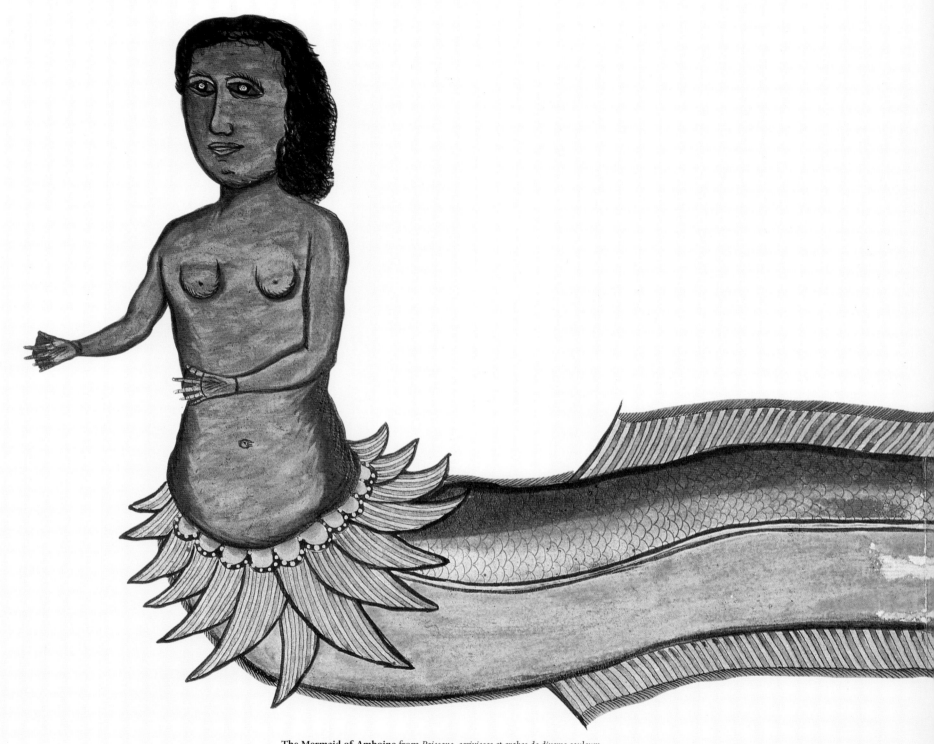

The Mermaid of Amboine from *Poissons, ecrivisses et crabes de diverse couleurs*
1717
Colored woodcut book illustration

BUT SHE, WITH ASTOUNDING VIGOR, EMERGED STRAIGHT FROM THE SEA AS FAR AS THE WAIST AND PUT HER ARMS AROUND MY NECK, ENVELOPING ME IN A SCENT I HAD NEVER SMELLED BEFORE, THEN LET HERSELF SLITHER INTO THE BOAT: BENEATH HER GROIN, BENEATH HER GLUTEAL MUSCLES, HER BODY WAS THAT OF A FISH, COVERED IN MINUTE SCALES OF BLUE AND MOTHER-OF-PEARL, AND ENDING IN A FORKED TAIL WHICH WAS SLOWLY BEATING THE BOTTOM OF THE BOAT. SHE WAS A MERMAID.

—*Giuseppe di Lampedusa*
(1896–1957)
ITALIAN WRITER

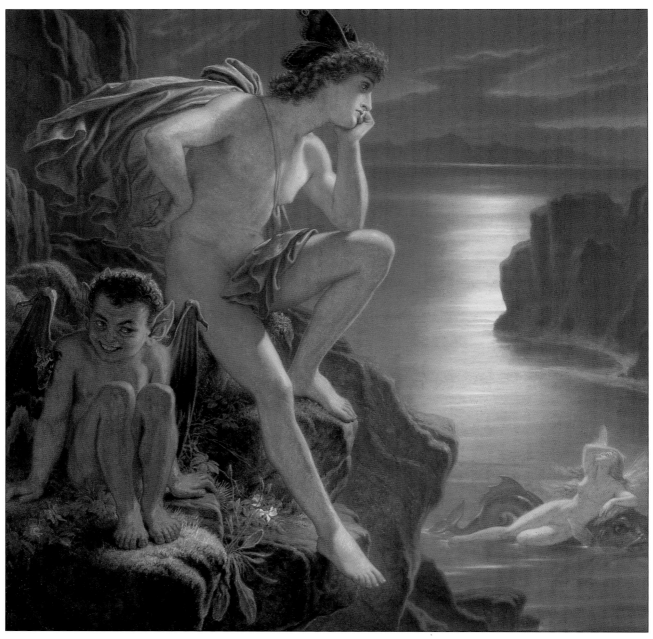

Oberon and the Mermaid
Sir Joseph Noel Paton
1883
Oil on canvas

THE MERROW

(AS DESCRIBED BY WILLIAM BUTLER YEATS IN "Irish Fairy & Folk Tales")

The Merrow, or if you write it in the Irish, *Moruadh* or *Murrughach*, from *muir*, sea, and *oigh*, a maid, is not uncommon, they say, on the wilder coasts of Ireland. The fishermen do not like to see them, for it always means coming gales. The male Merrows (if you can use such a phrase—I have never heard the masculine of Merrow) have green teeth, green hair, pig's eyes, and red noses; but their women are beautiful, for all their fish tails and little duck-like scales between their fingers. Sometimes they prefer, small blame to them, good-looking fishermen to their sea lovers. Near Bantry, in the last century, there is said to have been a woman covered all over with scales like a fish, who was descended from such a marriage. Sometimes they come out of the sea, and wander about the shore in the shape of little hornless cows. They have, when in their own shape, a red cap, called a *cohullen druith*, usually covered with feathers. If this is stolen, they cannot again go down under the waves.

Red is the color of magic in every country, and has been so from the very earliest times. The caps of fairies and magicians are well-nigh always red.

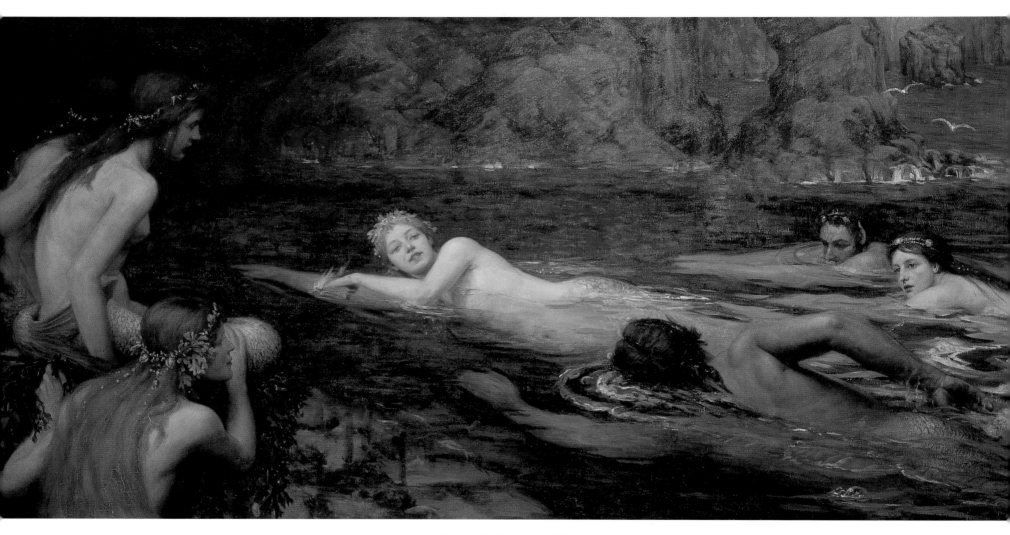

A Race with Mermaids and Tritons
Collier Smithers
1895
Oil on canvas

The sea

IS MOTHER-DEATH

AND SHE IS A MIGHTY FEMALE,

THE ONE WHO WINS,

THE ONE WHO SUCKS US ALL UP.

—*Anne Sexton*
(1928–1974)
AMERICAN POET

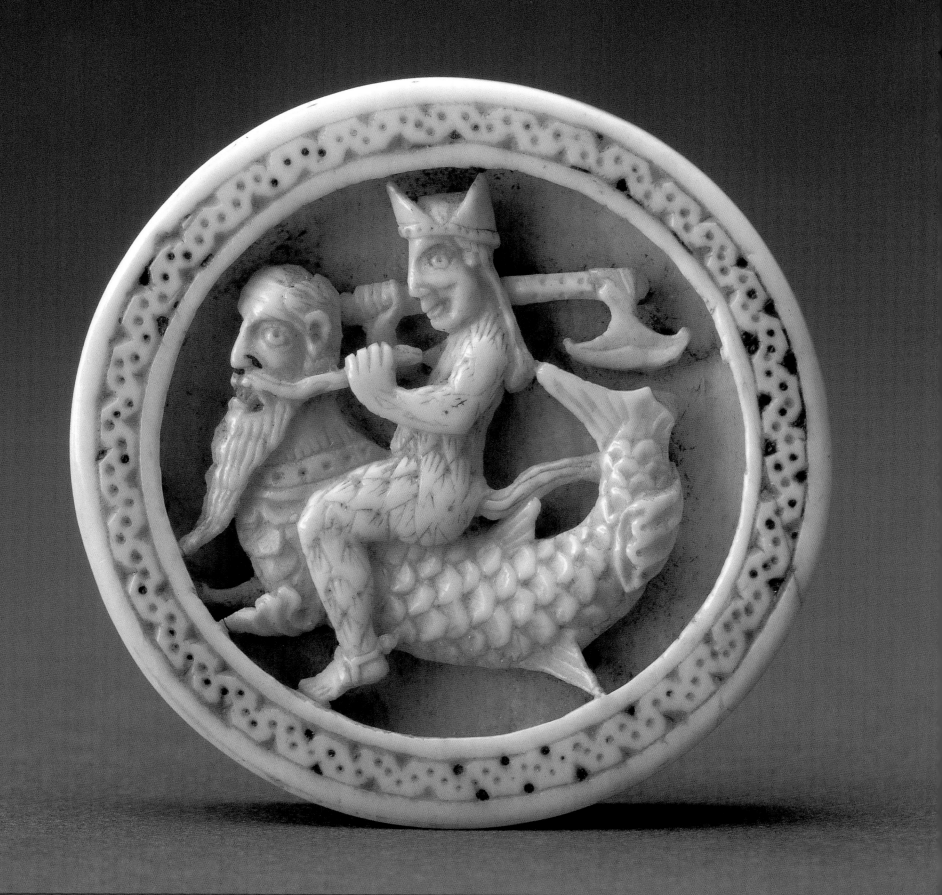

The sea, UNMATED CREATURE, TIRED AND LONE,

MAKES ON ITS DESOLATE SANDS ETERNAL MOAN.

—*Frederick William Faber*
(1814–1863)
BRITISH POET

Mitred personage riding a marine creature
Norway or Cologne, Germany
12th century
Walrus ivory backgammon game piece

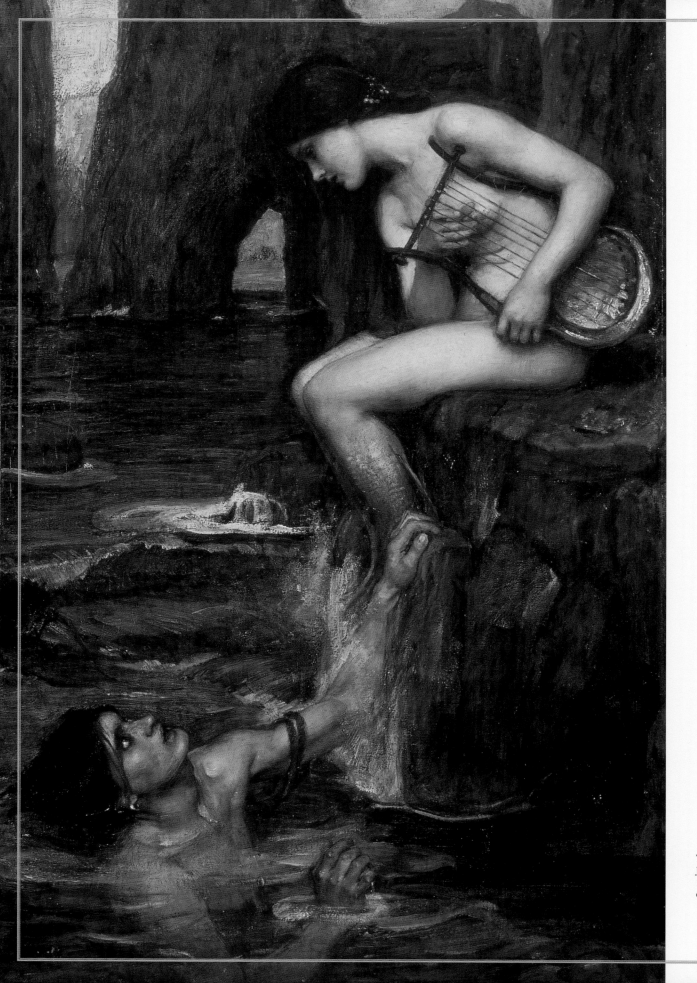

The Siren
John William Waterhouse
1900
Oil on canvas

WHO WOULD BE

A MERMAID FAIR,

SINGING ALONE,

COMBING HER HAIR

UNDER THE SEA

IN A GOLDEN CURL

WITH A COMB OF PEARL

ON A THRONE?

—Alfred Lord Tennyson
(1809–1892)
BRITISH POET

Mrs. Fitzgerland and the Merrow

One early morning, Dick Fitzgerald stood on the Dingle shore and stared out to sea when he chanced to see what he thought was a green seal upon the rocks. "Bless me!" he cried, and rolled up his trousers to go out to the mossy rocks to investigate. "Bless me twice over!" he exclaimed when he got a closer look, for it was not a seal at all but a girl combing seaweed from her long, green hair. She was a mermaid, he knew, for she had a tail and there was a little red hat beside her on the rock. He stuffed the hat in his pocket for safekeeping.

The mermaid did not see him at first, as her back was to him, but when his foot slipped into the water, she turned. She cried when she saw the corner of her hat peeking from out of Dick's pocket. He didn't want to hand over the magic hat until he saw what luck would come from it, so he pulled a handkerchief out instead. She took it and said, trembling, "Are you going to eat me?"

"Eat you?" he cried. "No!"

"Then what will you do with me?" she asked.

"Yes, whatever will I do with you?" he echoed, for he wasn't sure what to say. He gazed at her and saw she was a lovely lass, even with her green head and webbed toes. "I suppose I might marry you, and make Dick Fitzgerald the luckiest man in Dingle."

Now the mermaid gazed upon Dick Fitzgerald. He had a lovely smile and curly black hair, and was far more handsome than any merman. "I suppose I might marry you, too," she said. "Mrs. Fitzgerald the Merrow does have a nice ring to it."

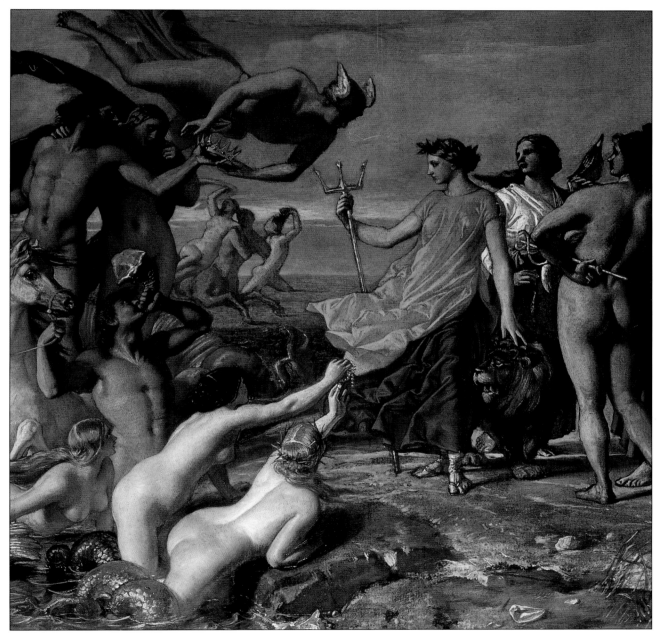

Neptune Resigning to Britannia the Empire of the Sea, detail
William Dyce
19th century

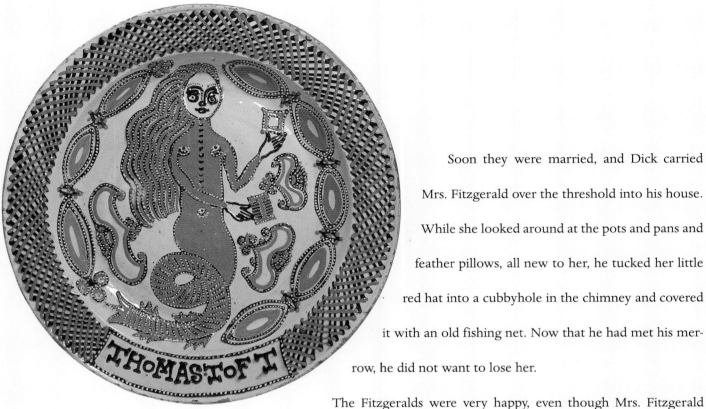

Mermaid dish
Thomas Toft
ca. 1670–80
Lead glazed earthenware
with trailed slip decoration

Soon they were married, and Dick carried Mrs. Fitzgerald over the threshold into his house. While she looked around at the pots and pans and feather pillows, all new to her, he tucked her little red hat into a cubbyhole in the chimney and covered it with an old fishing net. Now that he had met his merrow, he did not want to lose her.

The Fitzgeralds were very happy, even though Mrs. Fitzgerald was not much of a housekeeper and refused to cook fish. Every time she scorched the oatmeal or forgot to clean, Mr. Fitzgerald would say, "Mrs. Fitzgerland, whatever will I do with you?" and she would kiss him and laugh.

The couple had three children, and the mermaid hung starfish over their cradles and sang them to sleep with old sea songs, but they didn't take to the water. They were normal children and made for a normal family, and soon Mrs. Fitzgerland's memories of her sea life were faint. The children grew up and left home, and Mr. and Mrs. Fitzgerald were alone again. Her green hair had turned white, and they looked like an ordinary old couple. They felt like one too. Mrs. Fitzgerald seldom mentioned the ocean, and her husband rarely needed to ask, "Whatever will I do with you?" anymore.

One day, Dick had to travel to Tralee, and would be gone until teatime. Mrs. Fitzgerald decided she would surprise him by tidying up a bit, which she hadn't done for a very long time. She swept and scrubbed, and was quite pleased with the results until she saw cobwebs dangling from the chimney. She swung her broom about, and it snagged an old fishing net. The net fell to the floor and, with it, a red hat.

Mrs. Fitzgerald thought she'd seen the wee cap before, perhaps in a dream. "I might just try it on," she thought.

The moment the magical cap touched her head, her hair turned green again, and she looked just as she had on the morning Dick Fitzgerald first saw her. Her head flooded with memories of her sea family, and the merrow—for she was one fully again—could hear sweet songs enticing her back to the water. "I'll only go for a small visit," she decided, "and then come right back." Holding the red hat tightly to her head, she dove into the waves.

When Dick Fitzgerald came home, he found the front door open and the net on the floor. He knew what must've happened and rushed to the shore. At the water's edge, he called to his wife: "Come home, Mrs. Fitzgerald! Whatever will I do without you?"

He called and called, then sat down and stared out at the sea. And there he may still sit, even to this day.

I GROW OLD . . . I GROW OLD . . .

I shall wear the bottoms of my trousers rolled.

Shall I part my hair behind? Do I dare to eat a peach?

I shall wear white flannel trousers, and walk upon the beach.

I have heard the mermaids singing, each to each.

I do not think they will sing to me.

I have seen them riding seaward on the waves

Combing the white hair of the waves blown back

When the wind blows the water white and black.

We have lingered in the chambers of the sea

By sea-girls wreathed with seaweed red and brown

Till human voices wake us, and we drown.

—*T. S. Eliot*
(1888–1965)
AMERICAN-BORN BRITISH POET

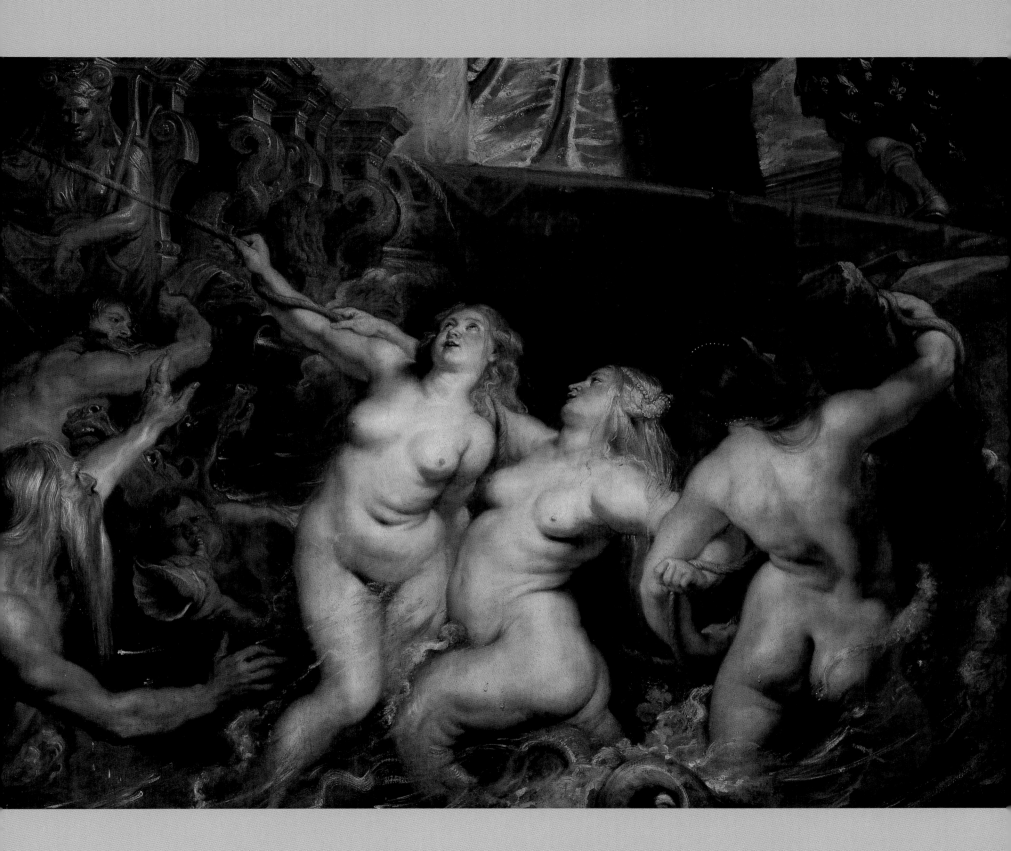

Sing, siren, for thyself, and I will dote;

SPREAD O'ER THE SILVER WAVES THY GOLDEN HAIRS,

And as a bed I'll take them, and there lie.

—*William Shakespeare*
(1564–1616)
BRITISH PLAYWRIGHT AND POET

Mermaids or sirens lulling sailors to sleep
with their songs from Bestiary, England
13th century
Manuscript illustration

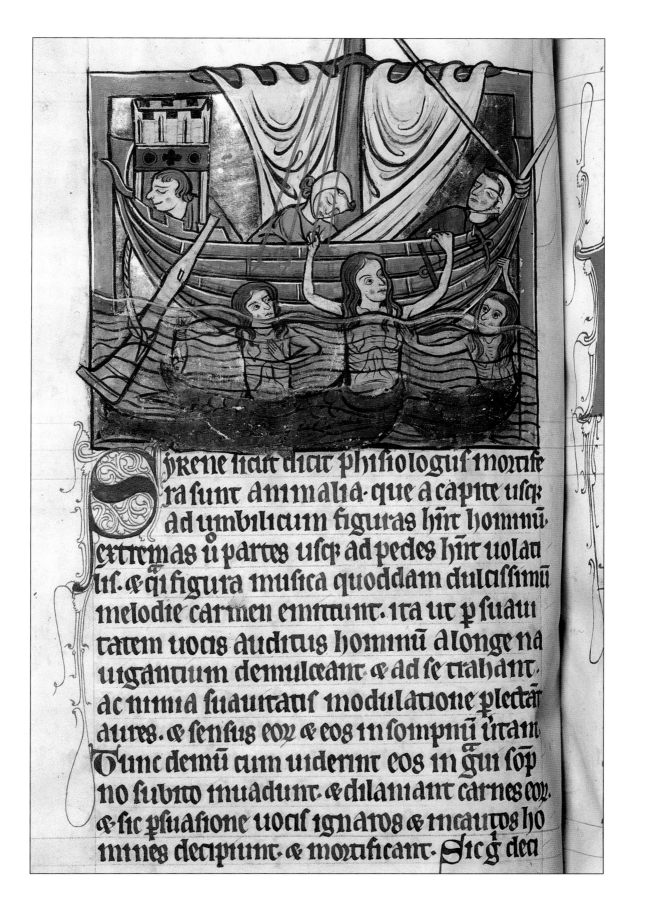

Syrene sicut dicit phisiologus mortife
ra sunt animalia. que a capite usq;
ad umbilicum figuras hīt hominū
extremas u̅ partes usq; ad pedes hīt uolatil
lis. & q̅ figura musica quoddam dulcissimū
melodie carmen emittunt. ita ut p suaui
tatem uocis auditus hominū alonge na
uigantium demulceant & ad se trahant.
ac nimia suauitatis modulatione plectā
dures. & sensus eo̅ & eos in sompnū u̅ram
Tunc demū cum uiderint eos in g̅̅u̅ so̅p
no subito inuadunt. & dilaniant carnes eo̅.
& sic p̅suasione uocis ignaros & incautos ho
mines decipiunt. & mortificant. Sic g̅ dei

The sea-violet

FRAGILE AS AGATE,

LIES FRONTING ALL THE WIND.

—Hilda Doolittle
(1886–1961)
AMERICAN POET

The Burghley Nef, salt cellar
Mark of Pierre le Flamand
ca. 1492
Nautilus shell mounted in silver parcel-gilt

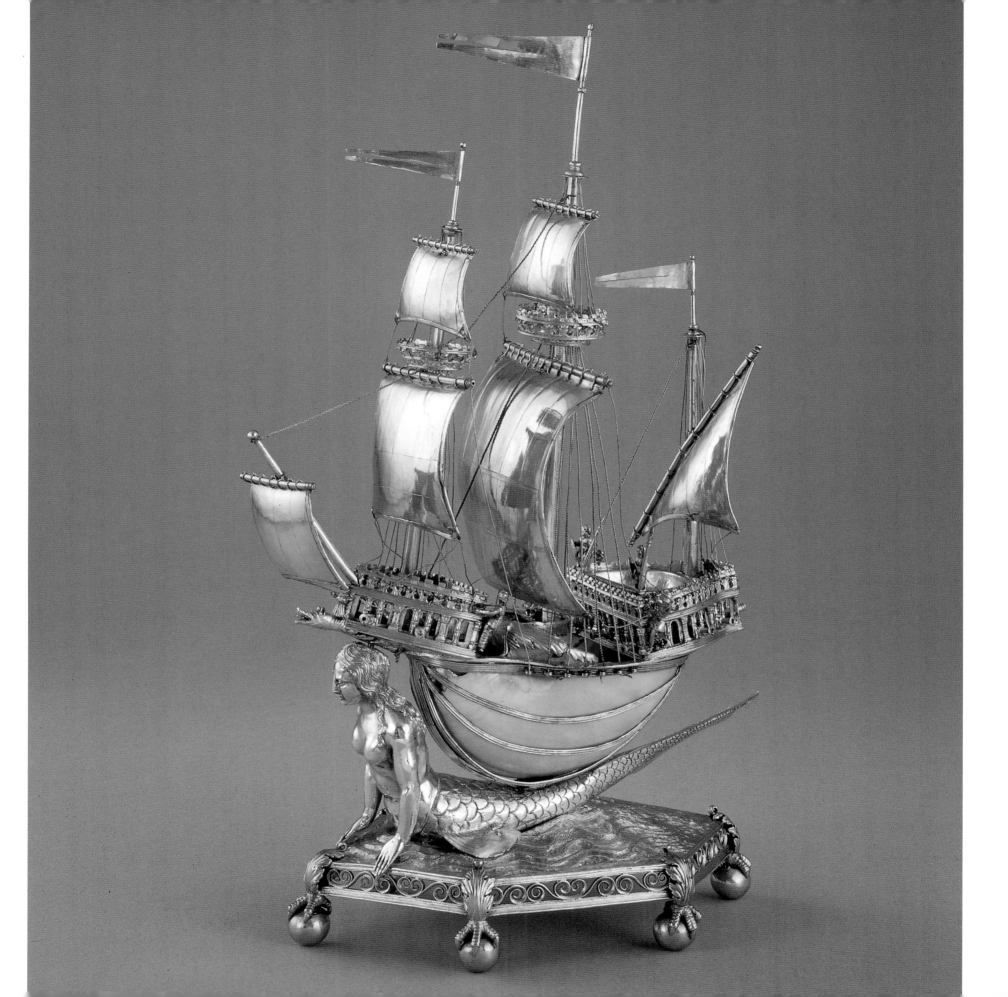

*A*nd all my days are trances

And all my nightly dreams

Are where thy dark eye glances

And where thy footstep gleams—

In what ethereal dances

By what eternal streams.

—*Edgar Allan Poe*
(1809–1849)
AMERICAN WRITER

A Siren in Full Moonlight
Paul Delvaux
1940
Oil on panel

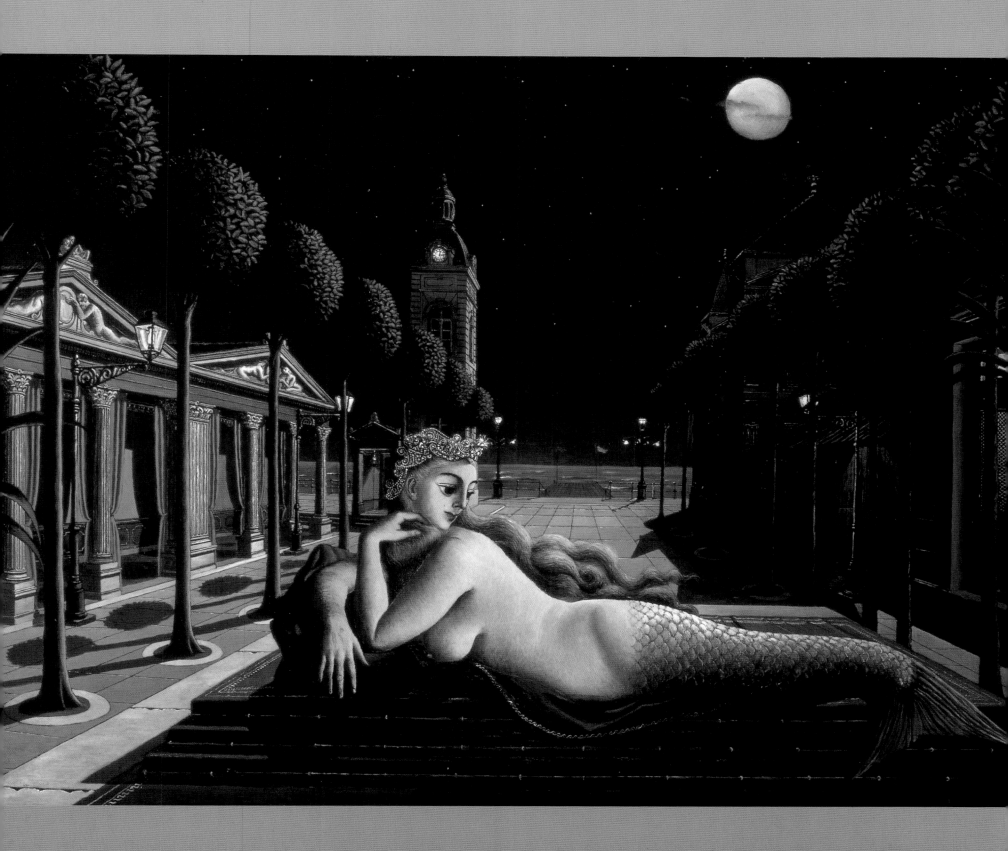

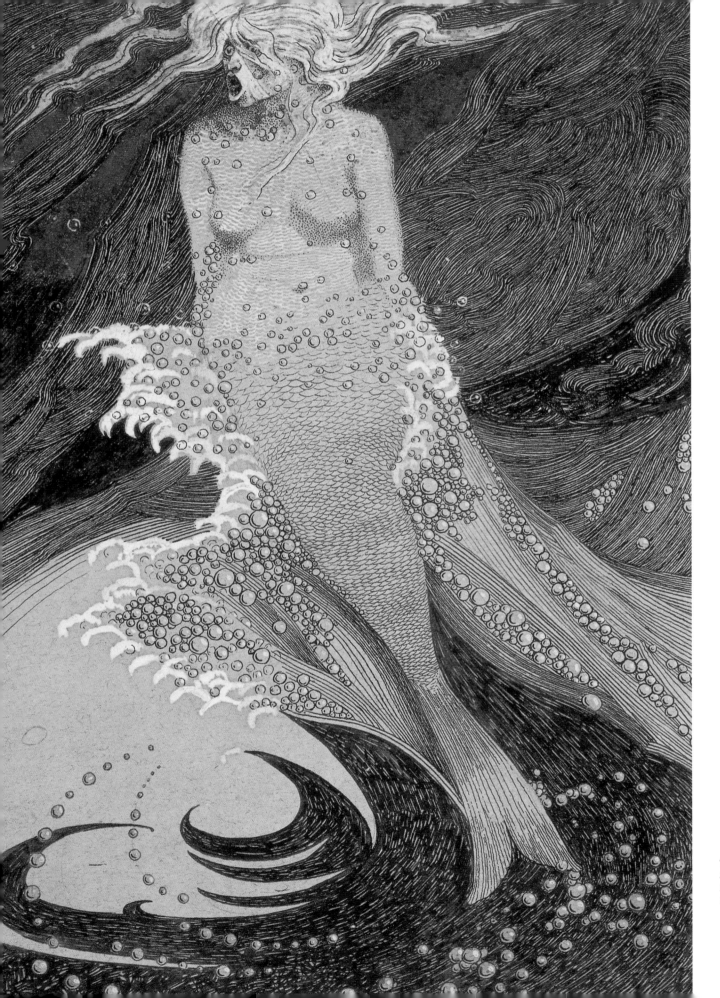

The Mermaid
Sidney Herbert Sime
20th century
Pen and ink with watercolor on paper

Sweet is the lore which Nature brings,

Our meddling intellect

Mis-shapes the beauteous forms of things

We murder to dissect.

Enough of science and of art:

Close up those barren leaves;

Come forth, and bring with you a heart

That watches and receives.

—*William Wordsworth*
(1770–1850)
BRITISH POET

THE STORY OF MELUSINE

The French medieval story of Melusine tells of Raymond, a count, who meets a strange and beautiful woman by a fountain in the forest. The woman, Melusine, suggests they marry, but there's one condition: She must be allowed complete privacy each and every Saturday, and Raymond must not ask why. The besotted man agrees, and finds his Melusine to be the perfect wife. His fortunes improve, he builds a chateau for them to live in, and all is well in the kingdom. Soon, they begin to have children. Unfortunately, all are born with strange deformities, making each one resemble an animal in one way or another. But they grow up to be unusually talented in different ways, which compensates for their unusual appearances.

One fateful day, after hearing townspeople gossip about his wife's mysterious Saturdays, Raymond grows not only curious but suspicious. He decides to peek into her room, despite his wedding vow, half-suspecting to find another man in her boudoir. Instead, he spies Melusine splashing about in the bath and sees, to his horror, that a long green tail has replaced her long, pale legs.

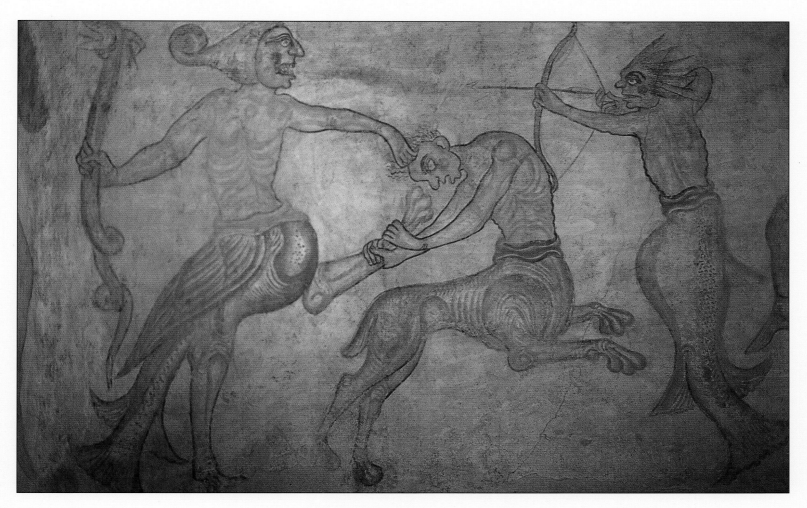

A battle between satyrs and other mythological creatures
13th century
Fresco, San Jacob in Castella, Alto Adige, Italy

At first, relieved that he has not been cuckholded, Raymond says nothing to his wife about

breaking their pact. But as troubles with their offspring escalate—culminating in one brother

killing the other—Raymond can no longer hold his tongue. Drunk with despair, he shouts out

that she and her beastliness must be to blame. When Melusine realizes their vow has been bro-

ken, she has no choice but to leave without a word through one of the windows of the chateau,

leaving only a mark of a single footprint where she last stood.

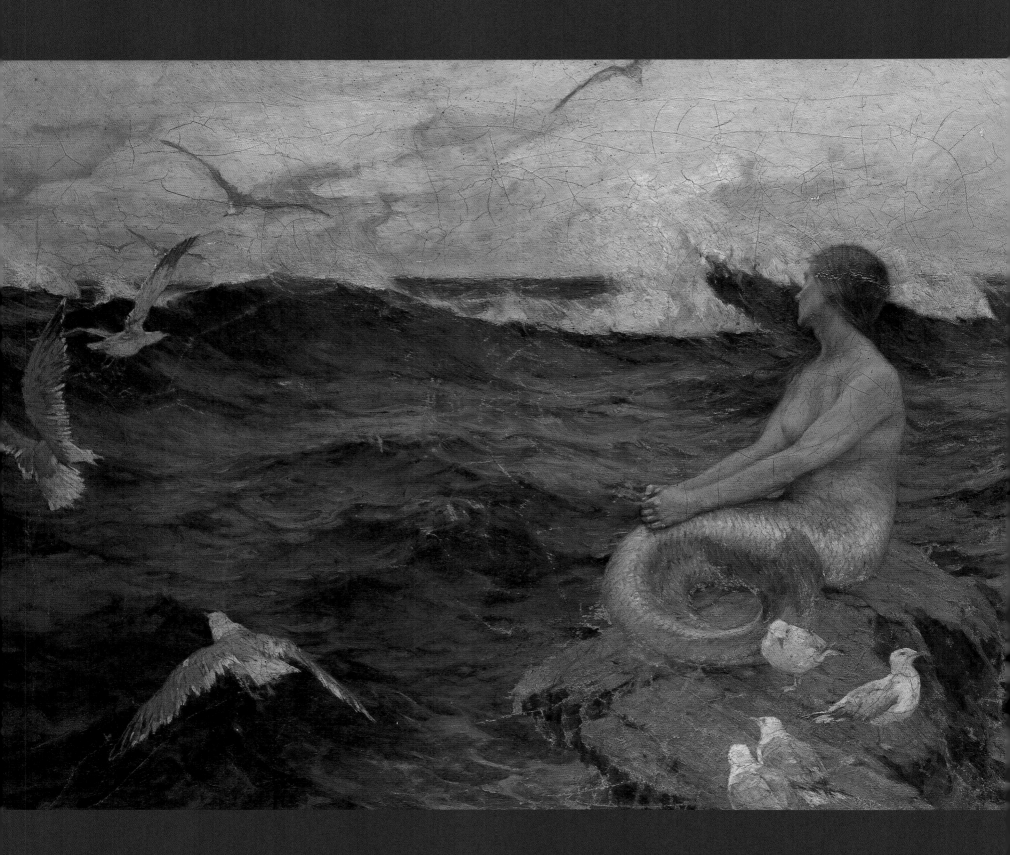

O golden-tongued Romance with serene lute!

Fair plumed syren! Queen of far-away!

Leave melodizing on this wintry day,

Shut up thine olden pages, and be mute:

Adieu! For once again the fierce dispute

Betwixt damnation and impassion'd clay

Must I burn through; once more humbly assay

The bitter-sweet of this Shakespearian fruit.

—*John Keats*
(1795–1821)
British poet

The Mermaid
Charles Padday
Oil on canvas

This morning

ONE OF OUR COMPANIE LOOKING OVER BOARD SAW A MERMAID . . . FROM NAVILL UPWARD, HER BACK AND BREASTS WERE LIKE A WOMAN'S (AS THEY SAY THAT SAW HER) HER BODY AS BIG AS ONE OF US; HER SKIN VERY WHITE; AND LONG HAIRE HANGING DOWN BEHINDE, OF COLOR BLACKE; IN HER GOING DOWNE THEY SAW HER TAYLE, WHICH WAS LIKE THE TAYLE OF A PORPOSSE AND SPECKLED LIKE A MACRELL.

—*From Henry Hudson's logbook*
JUNE 15, 1608

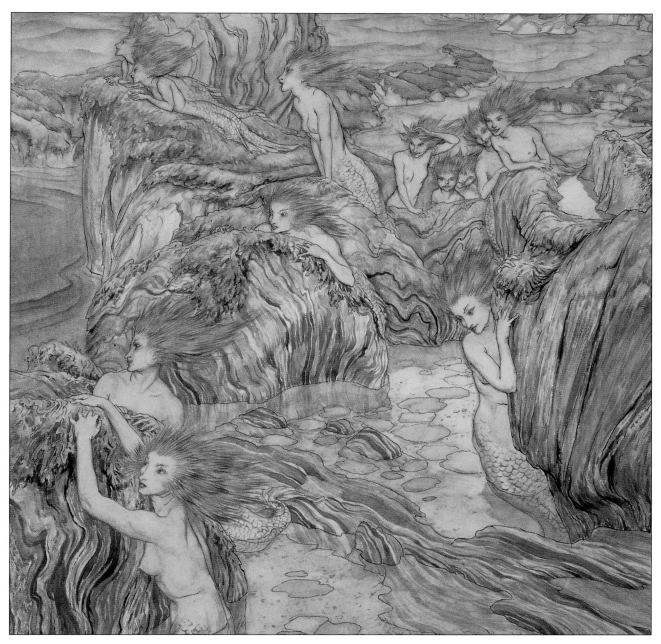

Aly, detail from Nathaniel Hawthorne's "Three Golden Apples"
Arthur Rackham
ca. 1922
Ink and watercolor on paper

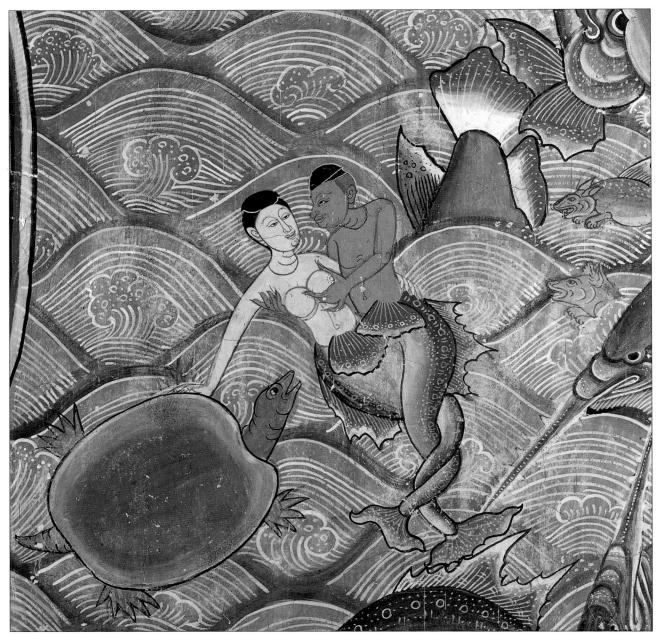

The Three Worlds, detail
School of Ratanakosin
2nd quarter, 19th century
Mural painting

Once more, once more,

FROM LEUCADE'S ROCK I DIVE

INTO THE SEA;

AND ONCE MORE

AMIDST THE WHITE FOAM DRUNK WITH LOVE.

—Anacreon
(C.582–C.485 B.C.)
GREEK POET

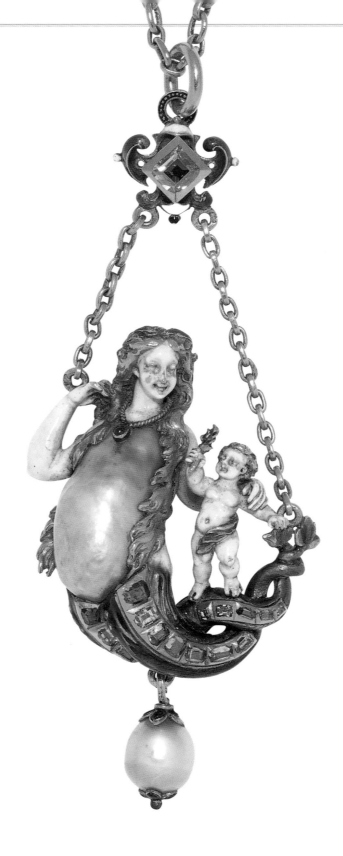

Mermaid
Louis Wiese
ca. 1890
Enameled gold pendant

FOR THE COLD STRANGE EYES OF A LITTLE MERMAIDEN

AND THE GLEAM OF HER GOLDEN HAIR.

. . . WE SHALL SEE, WHILE ABOVE US

THE WAVES ROAR AND WHIRL,

A CEILING OF AMBER,

A PAVEMENT OF PEARL.

—*Matthew Arnold*
(1822–1888)
BRITISH POET AND CRITIC

Her hair WAS A WET FLEECE OF GOLD, AND EACH SEPA-

RATE HAIR AS A THREAD OF FINE GOLD IN A CUP OF GLASS. HER BODY WAS AS

WHITE IVORY, AND HER TAIL WAS OF SILVER AND PEARL. SILVER AND PEARL WAS

HER TAIL, AND THE GREEN WEEDS OF THE SEA COILED AROUND IT; AND LIKE

SEA-SHELLS WERE HER EARS, AND HER LIPS WERE LIKE SEA-CORAL.

—*Oscar Wilde*
(1854–1900)
IRISH WRITER

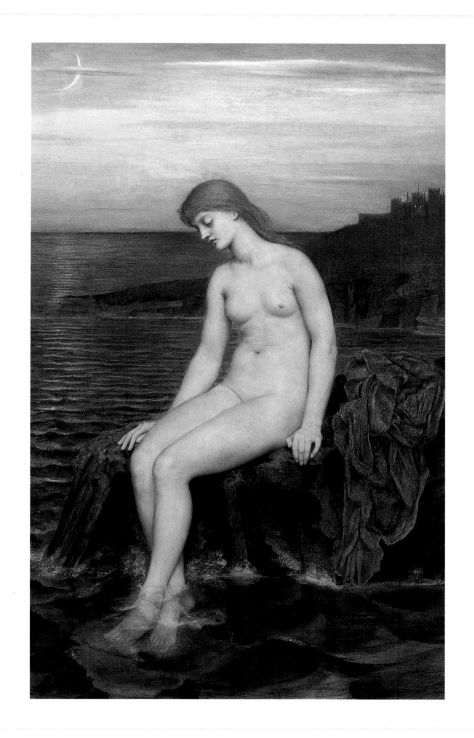

The Little Sea Maid
Evelyn De Morgan
1885–86
Oil on canvas

THE LITTLE MERMAID

BY HANS CHRISTIAN ANDERSEN

Far out in the ocean, where the water is as blue as the prettiest corn-flower, and as clear as crystal, it is very, very deep; so deep, indeed, that no cable could fathom it: many church steeples, piled one upon another, could not reach from the ground beneath to the surface of the water above. There lived the Mer-king. Since his wife had passed away, his elderly mother took care of him and his six daughters. The youngest mermaid was very quiet and thoughtful, and nothing pleased her more than hearing her grandmother's stories of the world of humans.

"When each of you reach your fifteenth year," said the grandmother, "you will have per-mission to rise up out of the sea, to sit on the rocks in the moonlight while the great ships are sailing by."

One by one the sisters turned fifteen, until finally it was the little mermaid's turn. Her grandmother put a wreath of white lilies and pearls on her head, and the mermaid floated up to the surface. There she saw a three-masted ship anchored in the water. There was much singing and dancing on board, and as the night grew darker, hundreds of lanterns lit the deck. The little mermaid swam about the ship, watching all the elegant and well-dressed people celebrating. The

most striking of all was a young prince, who could not have been more than sixteen. It was very late; yet the little mermaid could not take her eyes from the ship, or from the beautiful prince.

As she watched, the sea became restless, and a moaning, grumbling sound could be heard beneath the waves. Still the little mermaid remained by the cabin window, rocking up and down on the water. But soon, the waves grew and the storm became fierce; the waves rose mountains high, as if they would have overtopped the mast; but the ship dived like a swan between them, and then rose again on their lofty, foaming crests. Soon, the mainmast snapped asunder like a reed; the ship lay over on her side; and the water rushed in.

The little mermaid swam through the dangerous waves until she reached the prince. Holding his head above the water, she carried him into a bay and laid him on the sand. Then she sang to him in her lovely voice. When she heard people coming, she hid behind the rocks.

A young girl appeared and woke the prince, and he smiled gratefully at her. Soon others came to help him, and he was carried away from the shore.

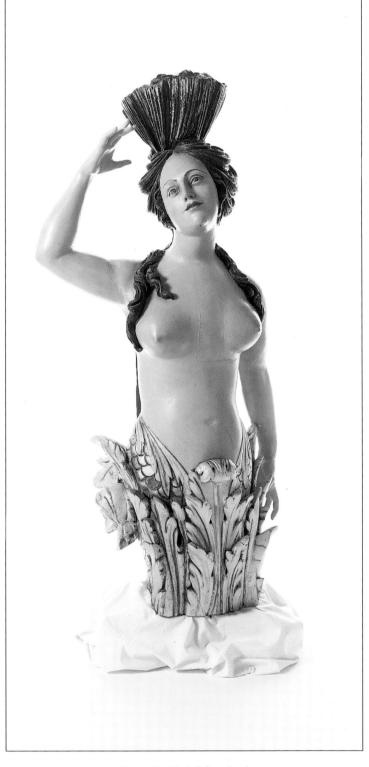

Mermaid with shell figurehead
19th–20th century
Wood polychrome

For many days afterward, the little mermaid returned to the place where she had left the prince. She saw the fruit ripen on the trees, she saw the snow melt on the mountains, but she never saw him.

At last she divulged her story to her sisters, and one of them showed her the palace where he lived. She longed to be one of the humans, and even asked her grandmother if they lived as long as mermaids did.

"No," said her grandmother. "Their lives are much shorter than ours. We live for three hundred years, and when our lives come to an

Siren sculpture
ca. 6th century B.C.E.
Bronze

end, we turn to foam upon the water. But a human has a soul that lives on after the body dies. It flies up to the stars."

She asked how she could get a human soul, and her grandmother told her: "If a human loved you dearly and married you, you could get one. But that will never happen. The very thing that makes you beautiful in the sea—your tail—is repulsive to humans."

This made the little mermaid sadder than ever. Still, she could not forget the prince, and one day she was filled with such longing that she made a terrible decision to seek the counsel of the sea witch. The fearsome witch gave her a special potion to turn her tail to legs, although she warned the little mermaid that each step she took would feel like knives. She warned her that she would never be able to return to mermaid form; that she would leave her father and sisters and grandmother forever; and worst of all, if the prince married someone else instead, she would turn to foam on the sea the morning after his wedding. The little mermaid agreed to this terrible price, but then the sea-witch added something more: the mermaid must give up her beautiful voice as payment for the potion.

The potion worked and the little mermaid made her way into the palace, where she quickly enchanted the young prince. They danced, they took walks, and they began to fall in love. In the

meantime, however, it had been arranged that the prince marry a princess from a neighboring kingdom. He would have to make the sea voyage to meet her, but before he did so, he confessed to the little mermaid that he was still in love with a woman he hadn't seen since the day she saved his life from a shipwreck. "She sang to me with her golden voice," said the prince, sadly. "A voice more beautiful than I've ever heard." Alas, the mermaid was powerless to tell him that she was that woman; that voice had been hers. "If I don't find that woman who saved me," he promised, "I should like to marry you."

The prince and the mermaid traveled together to the next kingdom. When they sailed into the harbor, church bells rang and the princess was brought to the ship for their meeting. "It is you!" he cried. "You're the one who saved me! My wish has come true!"

Indeed, it was the girl who had discovered the prince on the shore. The little mermaid felt her heart would break. The wedding ceremony was held immediately, and the mermaid held the bridal train. But she did not hear the music, nor did she pay attention to the ceremony. She knew this was her last day in this world. Late that night, she looked over the rail to the sea, and saw her sisters rising out of the water.

"We sold our hair to the sea witch in return for help," they told her, and indeed their long golden hair was shorn short. "She gave us this knife. When the sun rises, you must plunge it into the prince's heart. When his blood splashes on your feet, you will have a tail again, and you can join us in the sea once more."

The little mermaid took the knife and crept into the royal tent where the prince was sleeping with his bride. She gazed at the prince and the knife trembled in her hand: she ran out of the tent and flung the knife far away from her into the waves; the water turned red where it fell, and

the drops that spurted up looked like blood. She cast one more lingering, half-fainting glance at the prince, and then threw herself from the ship into the sea, and thought her body was dissolving into foam.

The sun rose above the waves, and warm rays fell on the cold foam of the little mermaid, who did not feel as if she were dying. She saw the bright sun, and all around her floated hundreds of transparent beautiful beings; she could see through them the white sails of the ship, and the red clouds in the sky; their speech was melodious, but too ethereal to be heard by mortal ears, as they were also unseen by mortal eyes. The little mermaid perceived that she had a body like theirs, and that she continued to rise higher and higher out of the foam. "Where am I?" asked she, and her voice sounded ethereal too, as the voice of those who were with her; no earthly music could imitate it.

"Among the daughters of the air," answered one of them. "A mermaid has not an immortal soul, nor can she obtain one unless she wins the love of a human being. On the power of another hangs her eternal destiny. But the daughters of the air, although they do not possess an immortal soul, can, by their good deeds, procure one for themselves. We fly to warm countries, and cool the sultry air. We spread the perfume of the flowers. After we have striven for three hundred years to all the good in our power, we are given a human soul. An immortal soul."

The little mermaid lifted her glorified eyes towards the sun, and floated through the water into the air. She saw the prince and his bride on the ship. They seemed to be searching for her. Invisible to everyone, the little mermaid floated to the ship, kissing the bride and smiling at the prince. Then she rose like a rosy cloud into the morning sky.

You should have seen her limbs become slack, the bones pliant, the nails lose their hardness. In the cold water, her most tender parts became liquid first: the black flowing hair, the fingers, the legs, the feet; and then the transformation of her other delicate limbs. Then her shoulders, back, him, and her breasts dissolved into small streams. And, finally, into the broken veins, in place of living blood, entered water, until nothing more remained to be grasped.

—Ovid
(43 B.C.–A.D. 17)
Roman poet

The Rhinemaidens teasing Alberich
Allegory of *The Rhinegold and Valkyrie*
Arthur Rackham
1910

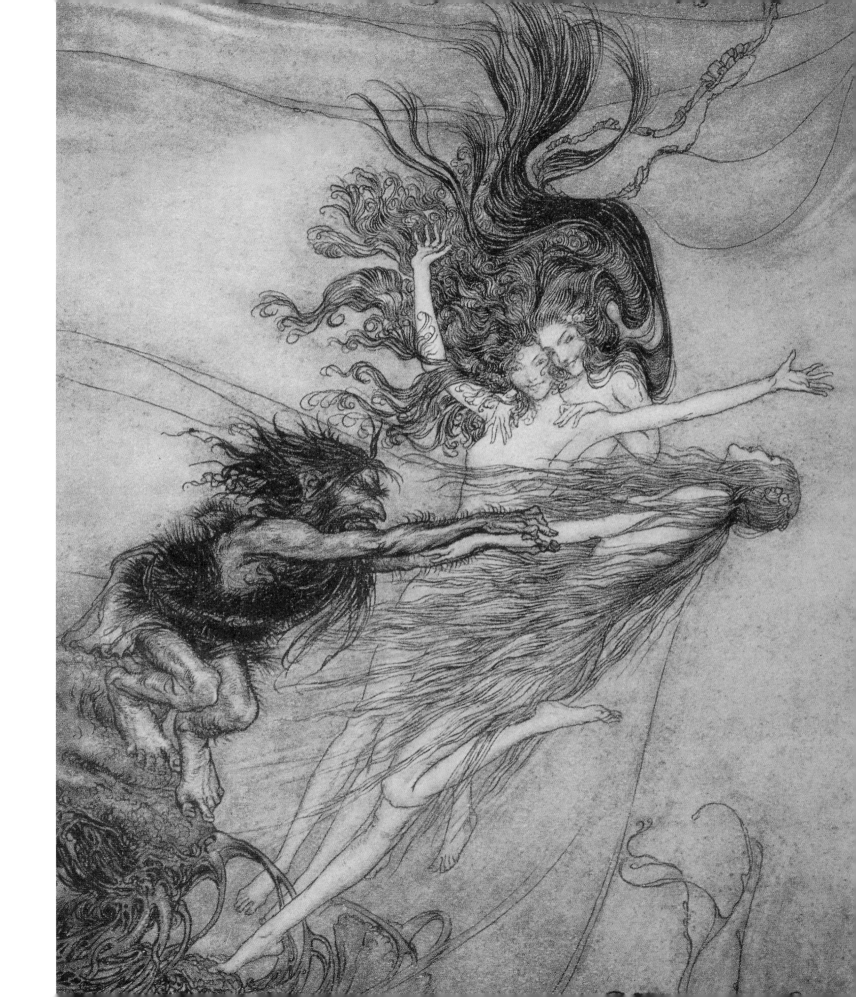

And if the earthly no longer knows your name

Whisper to the silent earth:

I'm flowing to the flashing water

say: I am.

—Rainer Maria Rilke
(1875–1926)
GERMAN POET

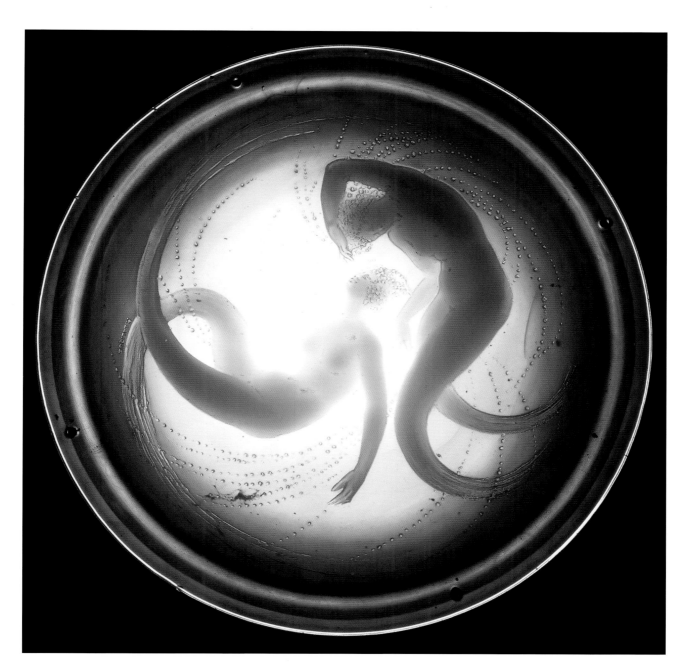

Deux Sirenes Plafonnier
Rene Jules Lalique
20th century
Glass

The Lorelei

"Flows the Rhine as flowing wine,
Bright in its unrest,
Sweet with odors of the vine;
Heaven in its breast."

So the boatman Hugo sung,
Long, long ago,
By the Lurley-berg that hung
In the sunset glow.

At that fateful rock, upraised
From its foamy base,
Suddenly the boatman gazed
With a stricken face.

On its summit, wondrous fair,
Shining angel-wise,
Sat a maid, with golden hair
And beseeching eyes.

From a shoulder's rosy sphere
All the robe that slid,
Ripple bright and water-clear,
Rather show'd than hid.

As her hair her fingers through
(Fingers pearly white)
Slowly pass'd, the diamond dew
Fell and broke in light.

But a gold harp from her feet
Lifted she ere long,
And its music, pulsing sweet,
Fed a wondrous song.

And the boatman, drifting fast,
Listen'd to his cost;
On the rocks before him cast!
In the whirlpool lost!

Then the Lorelei's luring form
Faded from the eye,
As a cloud fades, rosy warm,
In a purple sky.

—*Heinrich Heine*
(1797–1856)
GERMAN POET

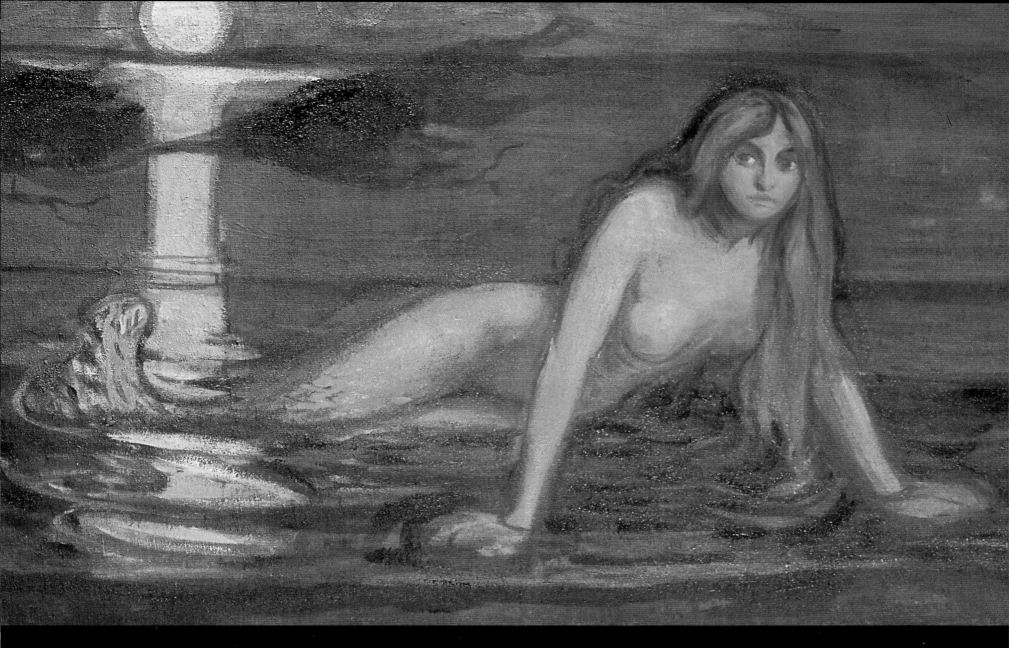

The Lady from the Sea, detail
Edvard Munch
1896

There's none but witches do inhbit here;

And therefore 'tis high time that I were hence.

She that doth call me husband, even my soul

Doth for a wife abhor. But her fair sister,

Possess'd with such a gentle sovereign grace,

Of such enchanting presence and discourse,

Hath almost made me traitor to myself:

But, lest myself be guilty to self-wrong,

I'll stop mine ears against the mermaid's song.

—*William Shakespeare*
(1564–1616)
BRITISH PLAYWRIGHT AND POET

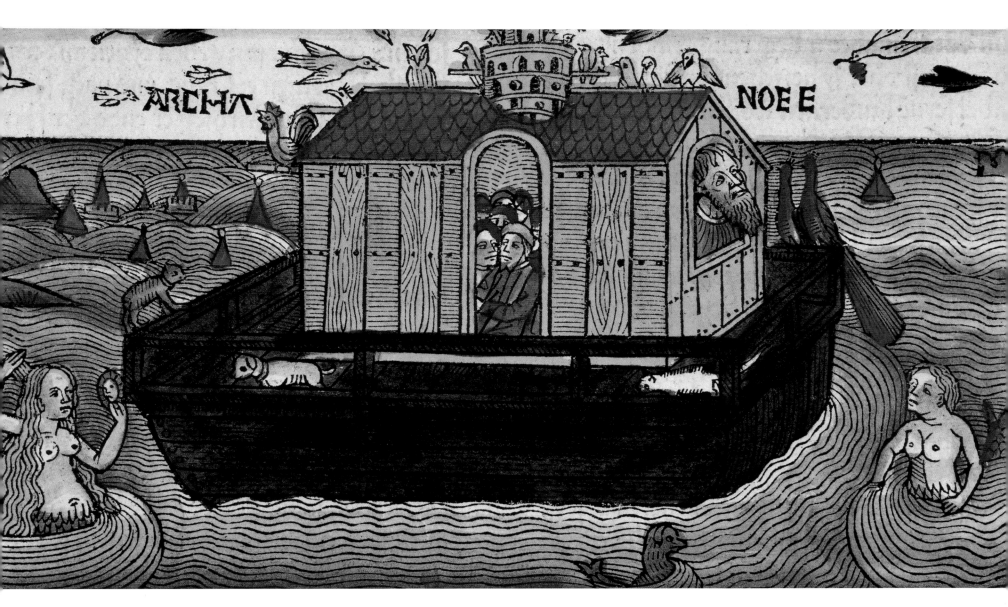

Noah's Ark, Nuremberg Bible
1483
Woodcut on paper

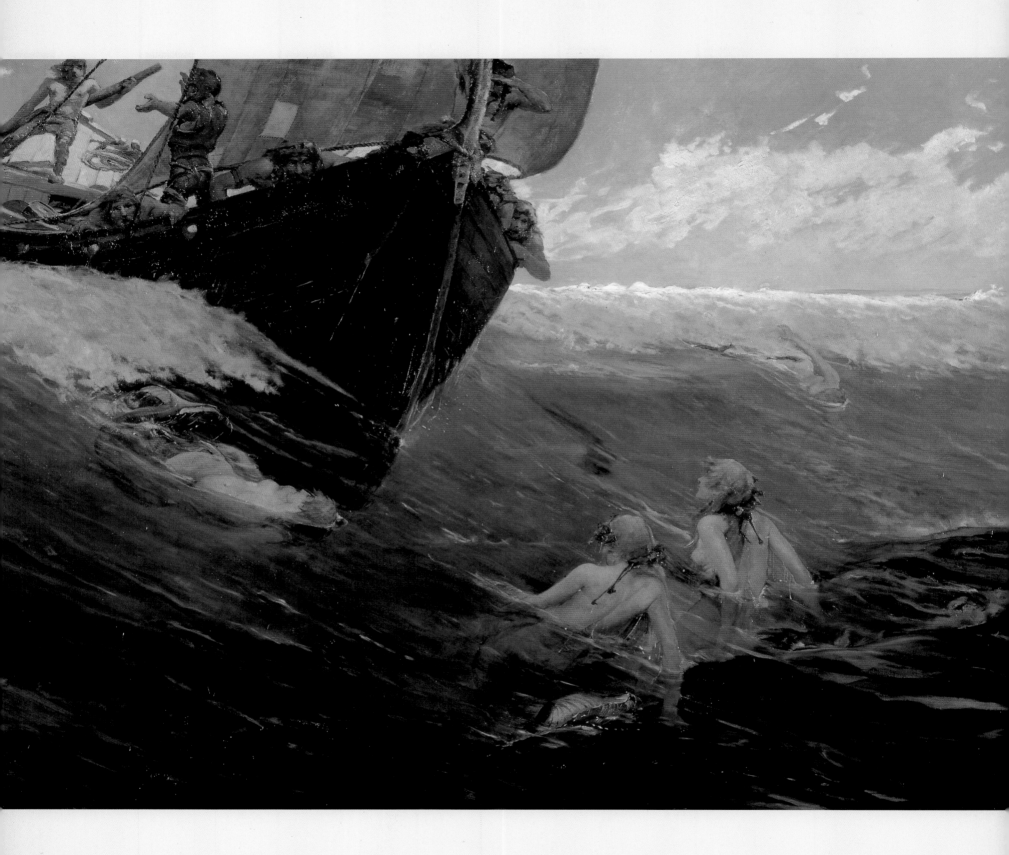

Teach me TO HEARE MERMAIDS SINGING,

OR TO KEEP OFF ENVIES STINGING.

—*Edmund Spenser*
(1552–1599)
BRITISH POET

The Mermaid's Rock
Edward Matthew Hale
1894
Oil on canvas

I am the star that rises from the sea, the twilight sea.

I bring men dreams that rule their destiny.

I bring the dream-tides to the souls of men;

The tides that ebb and flow and ebb again —

These are my secrets, these belong to me.

—*Dion Fortune*
(1890–1946)
BRITISH WRITER AND OCCULTIST

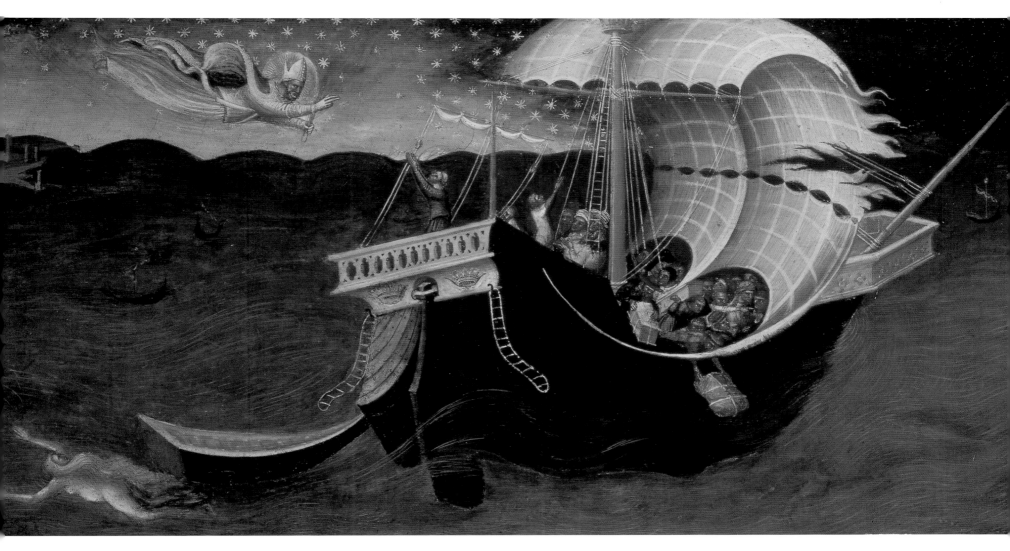

St. Nicholas rebuking the Tempest
Bicci di Lorenzo
15th century
Oil on panel

THE LEGEND OF UNDINE

Undine, also known as Ondine, is a water sprite whose name comes from the waves that are her home: the undulating waves called *unda* in Latin and *onde* in French. She captured the fancy of a nineteenth-century German novelist, Heinrich Karl de la Motte-Fouque, who drew upon the undines of folklore for his narrator in Undine, a romantic tale wildly popular in its day.

As Motte-Fouque tells it, Undine was a changeling who took the place of a fisherman's daughter, Bertalda, believed to be drowned. At the fisherman's hut, Undine met a nobleman, Sir Huldbrand von Ringstetten, who wanted to marry her. He did, but under fairy law, Undine could keep the human form she had assumed only as long as her husband was true to her. If he was unfaithful to Undine, she was doomed.

As fate would have it, Bertalda had not drowned, and when Huldbrand met her, he was smitten and determined to possess her. Undine still loved her husband and suffered in silence with the knowledge of his fickle attentions until the day her husband declared he loved another. At that moment, she melted back into the waves before his very eyes.

Huldbrand, a selfish and inconstant man, did not mourn the loss of Undine for long and was soon ready to take Bertalda for his wife. On the eve of his wedding, Undine rose from the water of a well and, with a parting kiss, took her former husband's life. Legend has it that, in the form of an eternal spring, she circles his grave to this day.

*Scylla the seamonster
Melos, Greece
5th century
Terracotta relief*

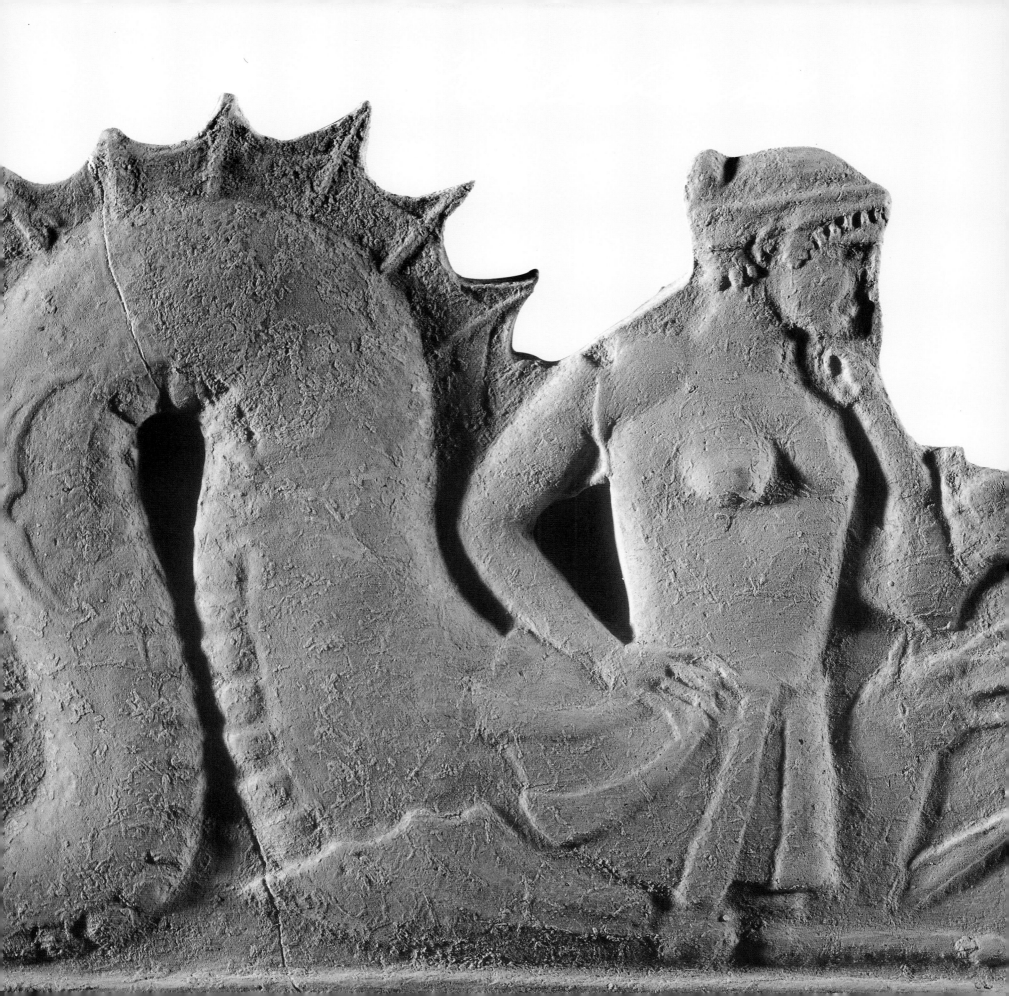

colorein album. quedam cinerium: utroz tn color in bo
nam partem ponitur. si palbum munditia, penitritum
penitentia designetur. huisdem eius generis sunt quu
penitent. z qui munde uuunt; color artlee. amodus
uite exemplum salutis: dat religiosis;

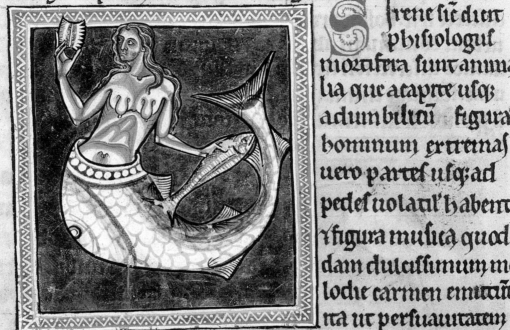

SIREN A.

Irene sic dicit
phisiologus
mortifera sunt anima
lia que aparte usoz
ad um biltui figuras
bominum ertreinas
uero partes usoz ad
pedes uolatil habent.
z figura musica quod
dam dulcissimum me
lodie carmen emittu
ita ut persuauitatem

uocis auditus bominum atonge nauigantium demul
ceant. z ad se trabant. acmnia suauitatis modulatione
plectant aures. z sensus corum z cos msompnum utunt.
Tunc demum cum uiderint cos mgui sompno subito

Mermaid or siren from the Ashmole Bestiary
early 13th century
Manuscript illustration

The sea has neither meaning nor pity.

—Anton Pavlovich Chekhov
(1860–1904)
RUSSIAN PLAYWRIGHT

Sirens I crept toward your caverns

You stuck your tongues out at the waves

And danced before their horses

Then clapped your angel wings

While I listened to those rival choirs . . .

—*Guillaume Apollinaire*
(1880–1918)
ITALIAN POET

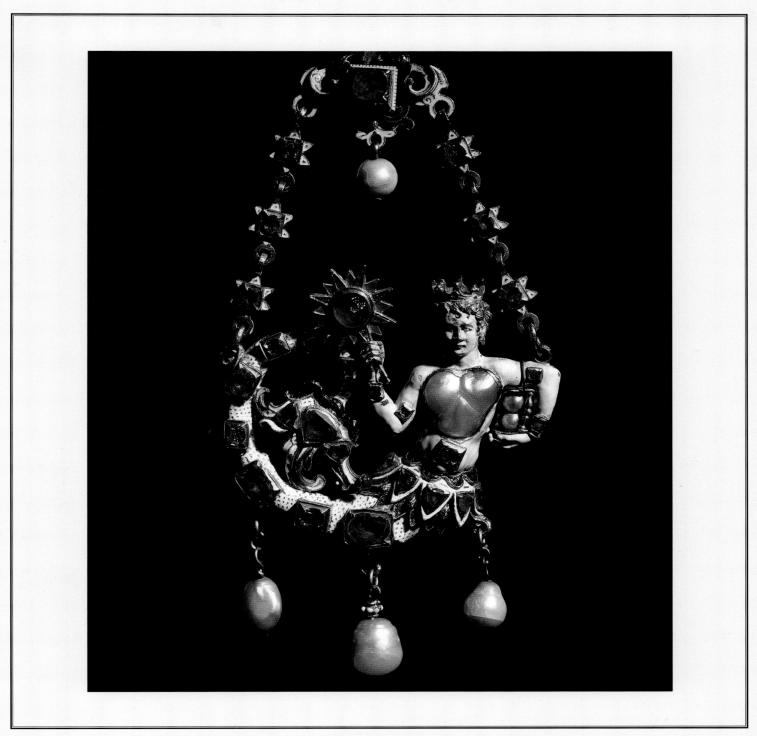

Siren holding sun pendant
Germany
ca. 1580–90
Gold, enamel, pearls, diamonds, and rubies

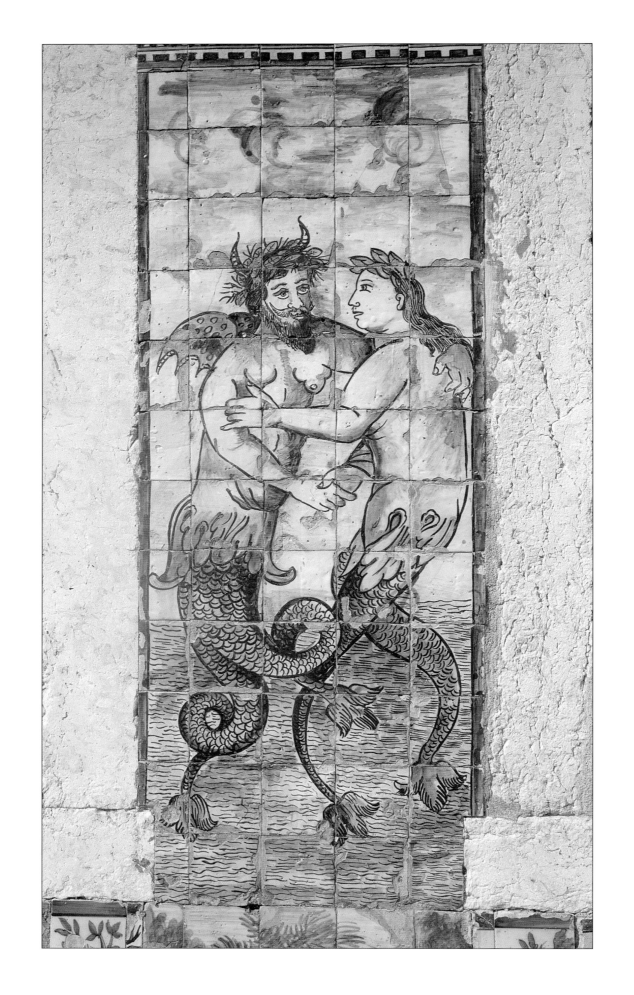

It is natural to indulge in the illusions of hope.

We are apt to shut our eyes to that siren until she "allures" us to our death.

—Gertrude Stein
(1874–1946)
AMERICAN WRITER

Merman with horns and mermaid
late 17th century
Tiles from Palacio de los Fronteira, Lisbon, Portugal

THE MERMAID AND THE MIST

A mermaid fell in love with an extraordinarily handsome young gentleman and took an opportunity of meeting him one day as he walked along the shore of the Isle of Man. She excitedly told him of her feelings, but he was so stunned by her appearance that his response to her was cold. This shattered the mermaid, and in revenge, she punished the whole island by covering it with a mist—so that all who attempted to carry on any commerce with it either never arrived, or traveled in vain up and down the seashore, or found themselves wrecked upon the cliffs. It is said this is why the island, to this day, cloaks itself in fog.

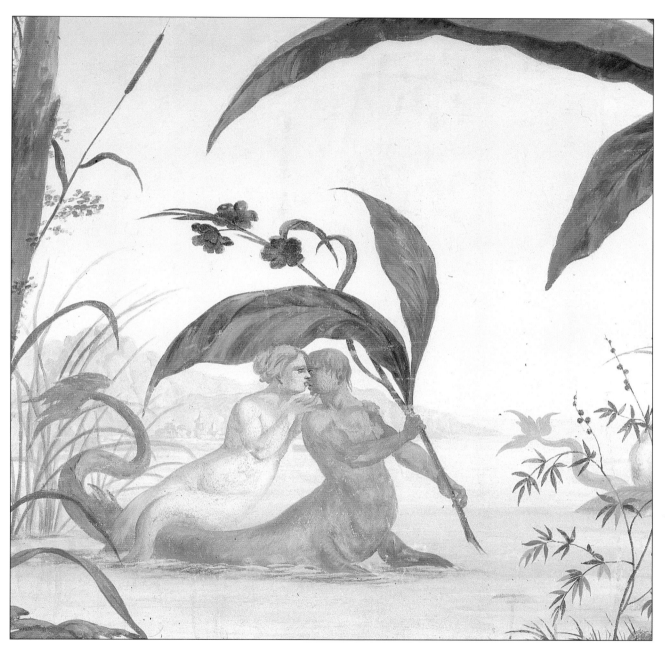

Centaur and mermaid, detail
ca. 1785
Fresco, Setais Palace, Portugal

At the bottom of the sea there is a house of crystal.

Toward an avenue of mother-of-pearl it looks.

At five o'clock a large golden fish comes to greet me.

Bringing me a large bouquet of coral flowers.

I sleep in a bed slightly bluer than the sea.

An octopus winks at me through the glass.

In the green wood around me ding dong . . . ding dong.

Sea-green, mother of pearl Sirens sing and rock.

And on my head the roughened points of the sea burn.

—Alfonsina Storni
(1892–1938)
ARGENTINE POET

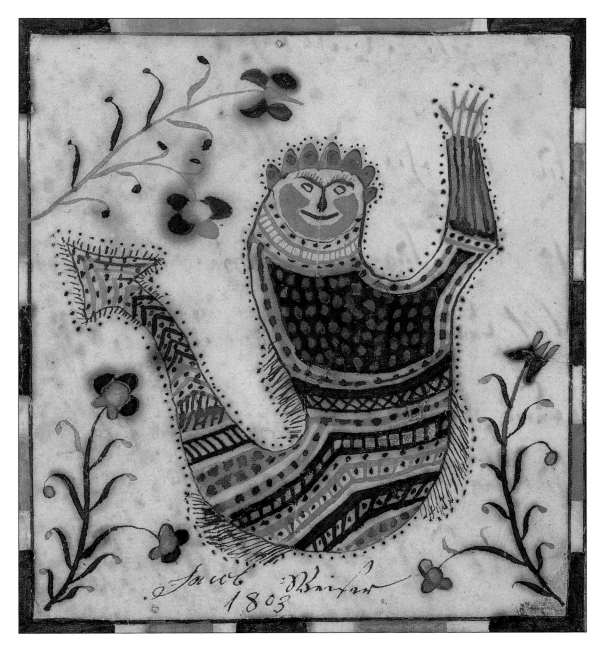

Merman
Attributed to Jacob Weiser, Pennsylvania
1803
Watercolor and ink on laid paper

The peerless cup afloat

OF THE LAKE-LILY IS AN URN SOME NYMPH

SWIMS BEARING HIGH ABOVE HER HEAD.

—Robert Browning
(1812–1889)
BRITISH POET

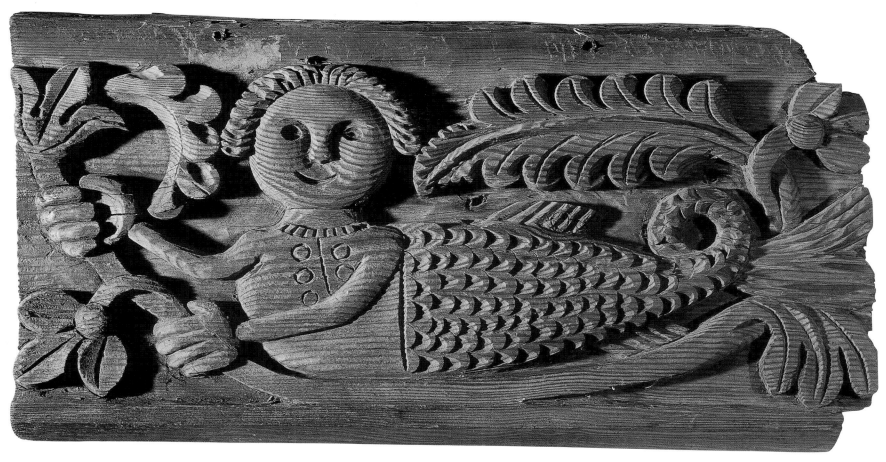

Mermaid, detail
18th century
Carved wood frieze, from house in Volga region, Russia

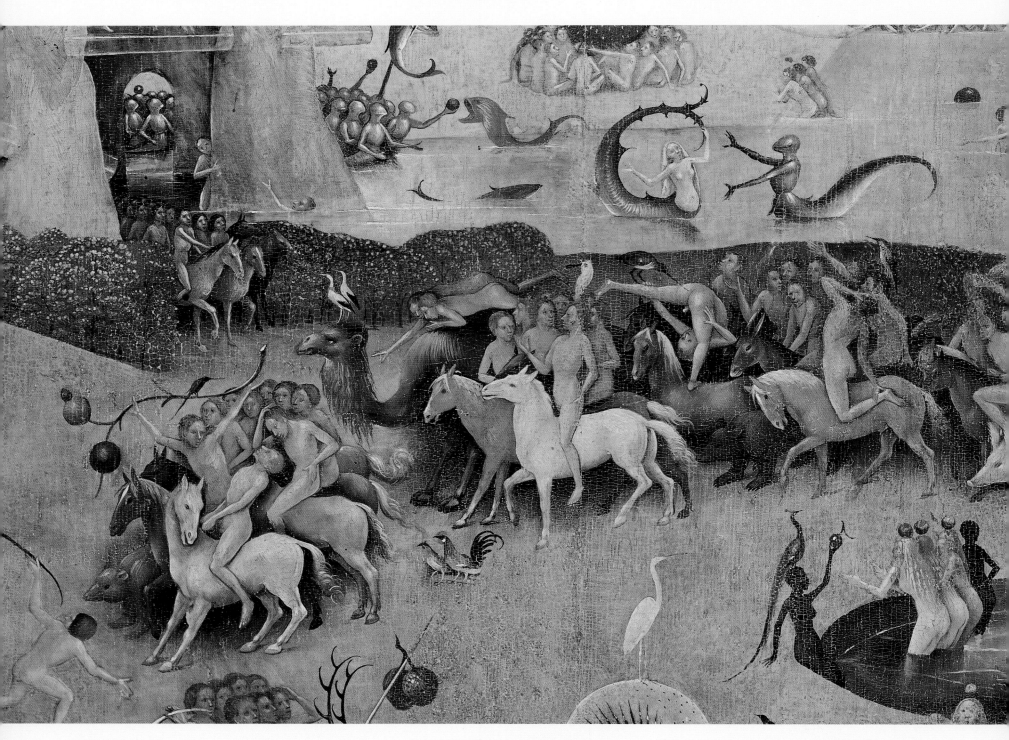

Garden of Delights, detail
Hieronymus Bosch
15th century
Oil on panel

THERE IS A WILLOW GROWS ASLANT A BROOK,

That shows his hoar leaves in the glassy stream;

There with fantastic garlands did she come

Of crow-flowers, nettles, daisies, and long purples

That liberal shepherds give a grosser name,

But our cold maids do dead men's fingers call them:

There, on the pendent boughs her coronet weeds

Clambering to hang, an envious sliver broke;

When down her weedy trophies and herself

Fell in the weeping brook. Her clothes spread wide;

And, mermaid-like, awhile they bore her up:

Which time she chanted snatches of old tunes;

As one incapable of her own distress,

Or like a creature native and indued

Unto that element: but long it could not be

Till that her garments, heavy with their drink,

Pull'd the poor wretch from her melodious lay

To muddy death.

—William Shakespeare
(1564–1616)
BRITISH PLAYWRIGHT AND POET

MERFOLK AROUND THE WORLD

In almost all cultures, mermen are as ugly as mermaids are lovely. The Irish merman is green-toothed, red-nosed, and squint-eyed. Luckily, he is not as cruel as he looks. In England, a mer-wife must keep watch so that her greedy mer-husband doesn't devour their mer-children for tea. In China, just catching sight of a merman is an ill omen and portends storms. In Russia, bearded and bloodthirsty mermen are half-man and half-frog, and disguise themselves as harmless floating logs. In Scandinavian lore, mermen are friendlier, often handsome and musical; Norwegian fishermen hope to catch a marmel, the thumb-sized merman that brings good luck.

Mermaids are often said to be shape-shifters. In both Asia and Europe, mermaids can cloak themselves in swan feathers. On the Isle of Man, mermaids escape capture by transforming into wrens, while Scottish mermen can change into a water horse called a kelpie. In the South Pacific, dolphins are often considered mermaids in disguise, while in Ireland, mermaids, or merrows, can take the forms of harmless little cows or gentle seals called the *roane*. In Japan, mermaids can become fish, like a salmon or a snapper. Eskimos tell tales of a gentle mermaid called a *nuyaqpalik*, and a much fiercer sea goddess who oversees all the ocean's creatures with a single eye.

No matter where in the world the lore is told, merfolk are almost always thought to be wise—the keepers of secret knowledge, cures to illnesses, and locations of riches. When they are captured, they usually share a secret or promise a magical reward.

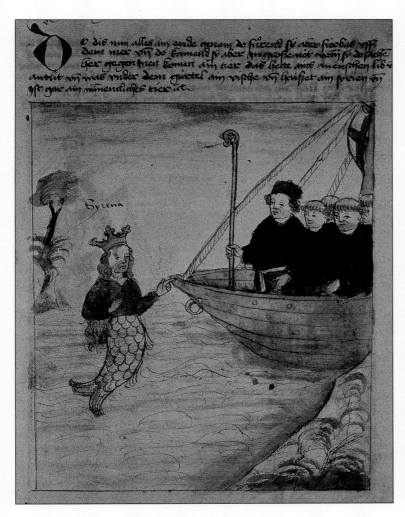

St. Brendan and a siren
ca. 1476
Miniature from the German translation of *Navigatio Sancti Brendani Abbatis*

Asparas: Indian Lute-Playing Water Spirit

Atargatis: Syrian Mermaid

Ben-Varry: Isle of Man Mermaid

Derceto: Philistine Mermaid

Dinny-Mara: Isle of Man Merman

Gwragged-Annwn: Scottish Mermaid

Hafvine: Norwegian Mermaids, Considered Unlucky

Lorelei: German Rhine Mermaids

Melusine: European Double Tail Mermaid

Merrow: Irish Mermaids

Naiads: Ancient Freshwater Spirits

Neck: Scandinavian Water Spirits

Neptune: Greek Sea God

Nereids: Mediterranean Water Nymphs without Tails

Ningyo: Japanese Mermaid

Nix or **Nixe:** German Water Spirits

Oannes: Babylonian Merman

Poseidon: Roman Sea God

Rusalki-Vodyany: Russian Water Spirits

Sea-Trow: Shetland Islands Water Spirits

Selkies: Scottish Merfolk

Tritons: Mediterranean Sea Gods

Vatea: Polynesian Porpoise God

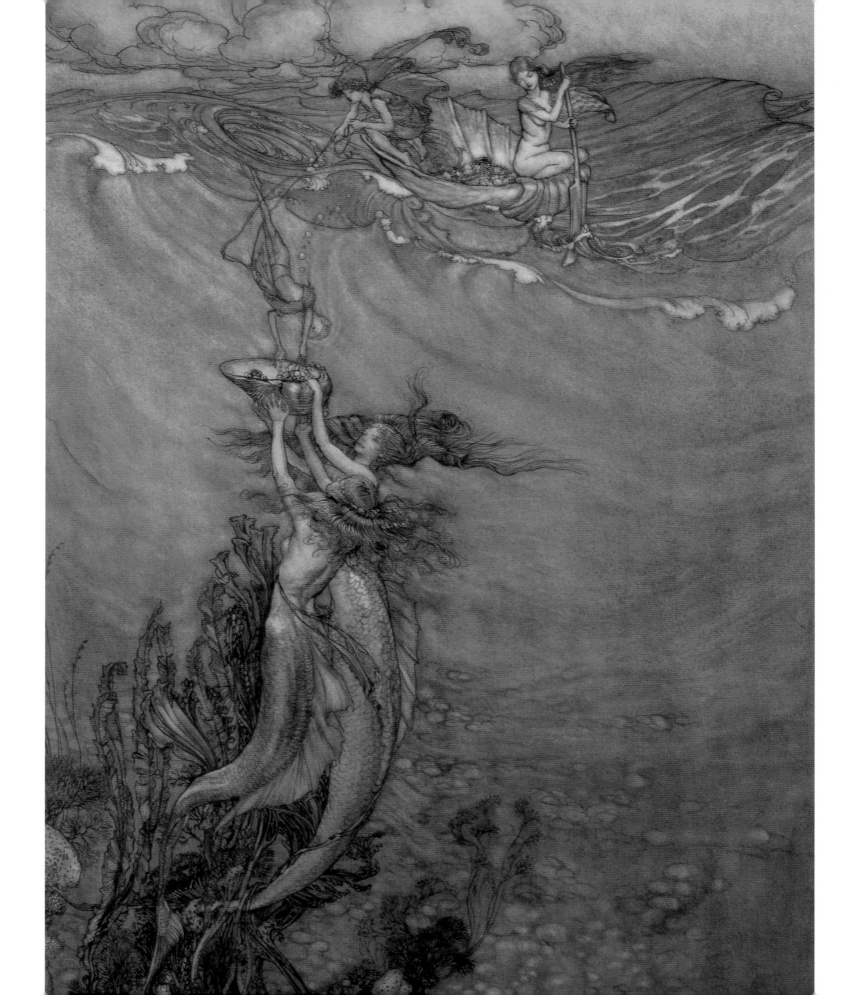

Eternity. It is the sea mingled with the sun.

—*Arthur Rimbaud*
(1854–1891)
FRENCH POET

Jewels from the Deep
Arthur Rackham
1909
Watercolor on paper

Sabrina fair

Listen where thou art sitting

Under the glassy, cool, translucent wave,

In twisted braids of lilies knitting

The loose train of thy amber-dropping hair;

Listen for dear honour's sake,

Goddess of the silver lake,

Listen and save.

—John Milton
(1608–1674)
BRITISH POET

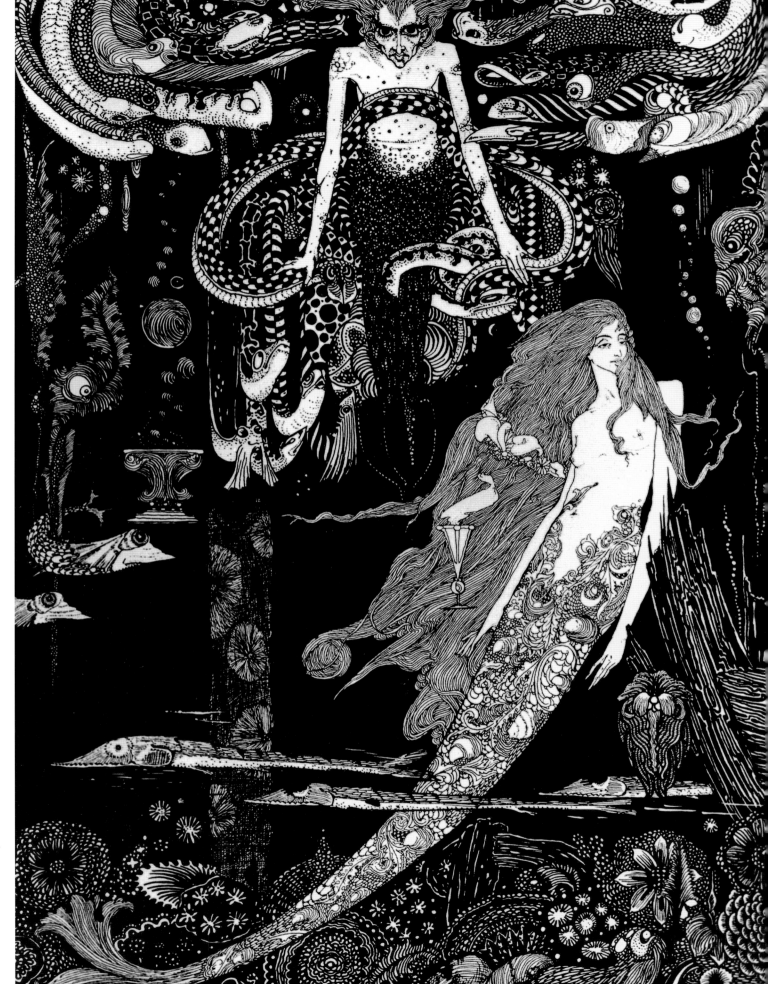

I Know What You Want
Illustration from "The Little Mermaid"
by Hans Christian Andersen
Harry Clarke
ca. 1910
Engraving

Front cover and p. 40: Mermaid weathervane (ca. 1850), by Warren Gould Roby. © Shelburne Museum, Shelburne, Vermont.

Front flap, spine, and p. 87: *The Little Sea Maid* (1885–86), by Evelyn De Morgan. The De Morgan Centre, London, UK; Bridgeman Art Library.

Back cover and p. 115: Centaur and mermaid fresco, detail (ca. 1785). Setais Palace, Portugal; The Art Archive/ Francesco Venturi.

Back flap and p. 84: Mermaid enameled gold pendant (ca. 1890), by Louis Wiese, Paris, France. Victoria and Albert Museum, London; Victoria and Albert Museum, London/ Art Resource, NY.

p. 5: *Composition, woman in front of the sea* (1943), by Paul Delvaux. © 2003 Artists Rights Society (ARS), New York/ADAGP, Paris. Private Collection; Bridgeman Art Library.

p. 7: *Capt. Hailborne at St. Johns Newfoundland* (1655). The Mariners' Museum, Newport News, VA.

p. 9: *The Triumph of Neptune* (first-half 17th century), by Frans II the Younger Francken. Private collection; Johnny Van Haeften Ltd., London/ Bridgeman Art Library.

p. 11: *Rheingold,* first scene (1888), by Ignace Henri Jean Fantin-Latour. Hamburg Kunsthalle, Hamburg, Germany; Bridgeman Art Library.

p. 13: Anthropomorphic figure (15th century), Italian School. San Giacomo in Castelaz, Termeno, Italy; Bridgeman Art Library.

p. 14: *Mermaid with her Offspring* (ca. 1860s–1898), by Sir Edward Burne-Jones. Private collection; Bridgeman Art Library.

p. 17: *The Fisherman and the Syren* from a ballad by Goethe (ca. 1856–58), by Frederic Leighton. Bristol City Museum and Art Gallery, UK; Bridgeman Art Library.

p. 19: Nereid or sea nymph, detail (3rd century), Roman. Archaeological Museum Hippone Algeria; The Art Archive/ Dagli Orti.

p. 21: St. Martin's watersprite, detail (ca. 1160). St. Martin, Zillis, Switzerland; Erich Lessing/ Art Resource, NY.

p. 23: A Siren, detail (12th century), by Pantaleone. Mosaic floor from Cattedrale Otranto, Italy; Erich Lessing/Art Resource, NY.

p. 25: *The Rhine Maidens* from Richard Wagner's *Siegfried and the Twilight of the Gods* (1911), by Arthur Rackham. © Reproduced with the kind permission of the family of Arthur Rackham. Private collection; Bridgeman Art Library.

p. 26: *Ulysses and the Sirens* (1910), by Herbert James Draper. Leeds Museums and Galleries (City Art Gallery), UK; Bridgeman Art Library.

p. 29: Pearl hunting (1570–75), by Alessandro Allori. Studiolo, Palazzo Vecchio, Florence, Italy; Scala/ Art Resource, NY.

p. 31: Venus at her toilette (ca. A.D. 98), Roman. Djemila, Algeria, North Africa; Archaeological Museum Djemila, Algeria; The Art Archive/ Dagli Orti.

p. 33: Allegory on the operas of Giacomo Puccini (1900). Puccini House Torre del Lago; The Art Archive/ Dagli Orti (A).

p. 35: *Fairies and Fauns on the Seashore* (19th century), by Alfred Thompson. The Maas Gallery, London, UK; Bridgeman Art Library.

p. 36: Sea monsters or mermen (late 17th century). Tiles from Palacio de los Fronteira, Lisbon, Portugal; The Art Archive/ Nicolas Sapieha.

p. 39: *The Dance of the Sea* (1883), by Charles Edouard Boutibonne. Private collection; Whitford Fine Art, London, UK/ Bridgeman Art Library.

p. 43: Sirens accompanying the boats (15th century), by Benoit de Ste. Maure. Bibliothèque Nationale, Paris, France; Snark/ Art Resource, NY.

p. 45: The Sirens from the Ulysses Cycle (1580), by Alessandro Allori. Banca Toscana Palazzo Salviati, Florence, Italy; Erich Lessing/ Art Resource, NY.

p. 46: Mermaid (1825–50). Abby Aldrich Rockefeller Folk Art Museum, Colonial Williamsburg Foundation, Williamsburg, VA.

p. 49: *One Thousand and One Nights,* (ca. 1940s), by Marc Chagall. © 2003 Artists Rights Society (ARS), New York/ ADAGP, Paris. Kunstmuseum, Dusseldorf, Germany; Bridgeman Art Library.

p. 51: Mermaid and Dolphin from *A Midsummer Night's Dream* (1908), by Arthur Rackham. © Reproduced with the kind permission of the family of Arthur Rackham. Victoria and Albert Museum, London, UK; Bridgeman Art Library.

pp. 52–53: *The Mermaid of Amboine* (1717). British Library, London, UK; Bridgeman Art Library.

p. 54: *Oberon and the Mermaid* (1883), by Sir Joseph Noel Paton. The Fine Art Society, London, UK; Bridgeman Art Library.

p. 56: *A Race with Mermaids and Tritons* (1895), by Collier Smithers. Whitford and Hughes, London, UK; Bridgeman Art Library.

p. 58: Mitred personage riding a marine creature, backgammon game piece, (12th century), Norway or Cologne, Germany. Louvre, Paris, France; Réunion des Musées Nationaux/ Art Resource, NY.

p. 60: *The Siren* (1900), by John William Waterhouse. Private collection; Bridgeman Art Library.

p. 63: *Neptune Resigning to Britannia the Empire of the Sea,* detail (19th century), by William Dyce. Forbes Magazine Collection, New York, USA; Bridgeman Art Library.

p. 64: Mermaid dish (ca. 1670–80), by Thomas Toft. Victoria and Albert Museum, London; Victoria and Albert Museum, London/ Art Resourcé, NY.

p. 67: *Medici Cycle,* detail of the Naiads (ca. 1621), by Peter Paul Rubens. Louvre, Paris, France; Peter Willi/ Bridgeman Art Library.

p. 69: Mermaids or sirens lulling sailors to sleep with their songs from Bestiary, England (13th century). Bodleian Library, Oxford, Bodley 764 folio 74v; The Art Archive/ The Bodleian Library.

p. 71: *The Burghley Nef,* salt cellar (ca. 1492), by Mark of Pierre le Flamand, Paris. Victoria and Albert Museum, London, UK; Victoria and Albert Museum/ Art Resource, NY.

p. 73: *A Siren in Full Moonlight* (1940), by Paul Delvaux. © Artists Rights Society (ARS), New York/ADAGP, Paris. Southampton City Art Gallery, Hampshire, UK; Bridgeman Art Library.

p. 74: *The Mermaid* (20th century), by Sidney Herbert Sime. Fitzwilliam Museum, University of Cambridge, UK; Bridgeman Art Library.

p. 77: A battle between satyrs and other mythological creatures (13th century). San Jacob in Castella, Alto Adige, Italy; Merilyn Thorold/ Bridgeman Art Library.

p. 78: *The Mermaid,* by Charles Padday. Private collection; Bonhams, London, UK/ Bridgeman Art Library. .

p. 81: *Aly,* illustration from Nathaniel Hawthorne's "Three Golden Apples" (ca.1922), by Arthur Rackham. © Reproduced with the kind permission of the family of Arthur Rackham. Private Collection; Chris Beetles, London, UK/ Bridgeman Art Library.

p. 82: *The Three Worlds,* detail, (2nd quarter, 19th century), School of Ratanakosin. Wat Kongkaram, Rajaburi, Thailand; Gilles Mermet/ Art Resource, NY.

p. 89: Mermaid with shell figurehead (19th–20th century). The Mariners' Museum, Newport News, VA.

pp. 90–91: Siren sculpture from Castel S. Mariano, Perugia (ca. 6th century B.C.E.). Museo Archeologico, Perugia, Italy; Alinari/ Regione Umbria/ Art Resource, NY.

p. 95: *The Rhinemaidens teasing Alberich* allegory from Richard Wagner's *The Rhinegold and Valkyrie* (1910), by Arthur Rackham. © Reproduced with the kind permission of the family of Arthur Rackham. Private collection; Bridgeman Art Library.

p. 97: *Deux Sirenes Plafonnier* (20th century), by Rene Jules Lalique. © 2003 Artists Rights Society (ARS), New York/ADAGP, Paris. Private collection; Bonhams, London, UK/ Bridgeman Art Library.

p. 99: *The Lady from the Sea,* detail (1896), by Edvard Munch. © 2003 The Munch Museum/ The Munch-Ellingsen Group/ Artists Rights Society (ARS), NY. Private collection; Bridgeman Art Library.

p. 101: *Noah's Ark,* Nuremberg Bible (1483). Private collection; Bridgeman Art Library.

p. 102: *The Mermaid's Rock* (1894), by Edward Matthew Hale. Leeds Museums and Galleries (City Art Gallery), UK; Bridgeman Art Library.

p. 105: St. Nicholas rebuking the Tempest (15th century), by Bicci di Lorenzo. Ashmolean Museum, Oxford, UK; Bridgeman Art Library.

pp. 106–107: Scylla the seamonster (5th century), Melos, Greece. British Museum, London, UK; Erich Lessing/ Art Resource, NY.

p. 108: Mermaid or siren from the Ashmole Bestiary (early 13th century), England. Ashmole 1511 folio 65v, Bodleian Library, Oxford; The Art Archive/The Bodleian Library.

p. 111: Siren holding sun pendant (ca. 1580–90), Germany. Palazzo Pitti, Florence; The Art Archive/ Dagli Orti (A).

p. 112: Merman with horns and mermaid tile panel (late 17th century). Palacio de los Fronteira, Lisbon, Portugal; The Art Archive/ Nicolas Sapieha.

p. 117: Merman (1803), attributed to Jacob Weiser, Pennsylvania. Abby Aldrich Rockefeller Folk Art Museum, Colonial Williamsburg Foundation, Williamsburg, VA.

p. 119: Mermaid, carved frieze detail (18th century). Folk Art Museum, Moscow, Russian Federation; Erich Lessing/ Art Resource, NY.

p. 120: *Garden of Delights,* detail (15th century), by Hieronymus Bosch. Museo del Prado, Madrid Spain; Scala/ Art Resource, NY.

p. 123: St. Brendan and a siren, (ca. 1476), German School. Universitatsbibliothek, Heidelberg, Germany; Bridgeman Art Library.

p. 124: *Jewels from the Deep* (1909), by Arthur Rackham. © Reproduced with the kind permission of the family of Arthur Rackham. Harris Museum and Art Gallery, Preston, Lancashire, UK; Bridgeman Art Library.

p. 127: *I Know What You Want,* Illustration from Hans Christian Andersen's "The Little Mermaid" (ca. 1910), by Harry Clarke. Bibliothèque des Arts Decoratifs, Paris, France; Archives Charmet/ Bridgeman Art Library.